S0-BRQ-143

Art has many faces *The Nature of Art Presented Visually*

Art has many faces *The Nature of Art Presented Visually*

by **Katharine Kuh**

Curator, Gallery of Art Interpretation, The Art Institute of Chicago

Typography and layout by Gyorgy Kepes, Professor of Visual Design
Massachusetts Institute of Technology

HARPER & BROTHERS PUBLISHERS

Table of Contents

Introduction

Introduction

In the world today words have assumed enormous power. They are, at best, a means of communication, but they can act as barriers, stifling understanding and response. Because the artist uses visual elements, not language, it is often impossible to interpret his work with means borrowed from literature. Words like rhythm, harmony, form and design can take on different meanings for music, dancing, poetry or the fine arts and even those terms concerned only with painting and sculpture are sometimes ambiguous unless demonstrated visually.

We read books and magazine articles about art, listen to lectures on the subject and submit to frequent gallery tours. The radio tells about art; films with lengthy commentaries show how to paint a picture, how to make sculpture, how to prepare a fresco. Though these are valid methods I am becoming more and more convinced that when words play a secondary role, art will be better understood in terms of itself. Statements about color, space, line or distance can be meaningless without accompanying examples and comparisons, but if the text is clarified visually, the observer is reassured less by literary comment, more by the evidence of his own eyes.

This, then, is a book with pictures accompanied by a running text and designed to explain art in terms of art. Words are used only as auxiliaries to point up and clarify the illustrations. Conventional adjectives and technical terms have been avoided, for the private language so often associated with art is sometimes more confusing than revealing. My hope is to *show* rather than tell, to combine *looking* with reading by limiting the text to statements which can be verified through visual examples, comparisons or contrasts. The reader is asked to take nothing on faith, though he must remember that certain emotional and personal reactions to art cannot always be explained. I do not claim that this is the only way to understand and enjoy art, but the freedom of looking first without the immediate prop of words can result in illuminating personal discovery, the experience taking on greater meaning when understanding has not been frozen by previous opinions. To be sure, there is still need for words, but they can act as corollaries, aiding instead of directing the eye.

My aim was not to prepare a book of reproductions with captions, but to choose all manner of visual material—photographs, charts, diagrams and special drawings as well as reproductions of sculpture, paintings and drawings. Because environment is the point of departure for most artists, many corollary photographs dealing with nature and daily life have been included. To understand art one must first be able to look searchingly at

familiar surroundings, and, in reverse, nature itself is often dramatically revealed to eyes sensitized by art.

This is not art history, nor is it critical evaluation. Wherever possible, works of superior quality have been selected, but the emphasis is on *why* and *how* rather than when and what. Dates, historical references and information about artists are included only when relevant, while in no case are individual works of art explained from all possible angles, for each example serves to develop but a single idea at a time. The purpose is to provide clues for future looking by using specific examples to explain more general ideas. Sometimes my interpretations are personal and should be taken as only one point of view. Artists whose work is here discussed may disagree with certain statements, denying motives and implications ascribed to them. But since each artist is conditioned by his past as is also each observer, rigid rules about seeing and understanding are impossible.

Though *Art Has Many Faces* is not chronologically arranged, it is best read in sequence, because sections toward the end depend on previous, more elementary explanations. The first half of the book breaks through historical barriers and deals with all periods, investigating art's infinite variations. As nature shows many different faces, so also does art, but the observer is more familiar with the ever-changing facets of the natural world and more willing to accept them. He becomes resentful when, accustomed to certain kinds of art, he must readjust to new forms. The whole question of *how* and *why* each artist works differently is developed at some length, first in relation to qualities like line, color, design, shape, form, light, space and texture. Other less formal reasons for art's variations are next examined —the limitations imposed by materials, the nature of tools and the effects of environment.

Since twentieth-century art has particular interest for twentieth-century eyes (and is not always understood by them) the entire second half of the book deals with contemporary art. I have tried to show how present-day movements grow out of the world around us, a world of speed, science, technology and immediacy. In doing this I chose what I consider the five most important influences, namely: simultaneity, the machine, war, psychoanalysis and modern urban life. How twentieth-century artists react to these stimuli, how their art depends on their surroundings, is explained by numerous juxtaposed photographs and comparisons.

Because this is a new and little-explored way of learning about art, it presents certain difficulties to a public more familiar with reading than looking, for the reader will constantly need to cor-

relate text with explanatory photographs, comparative drawings and charts. Some of these experiments were originally made in connection with the Gallery of Art Interpretation at the Art Institute of Chicago. Here, over a period of several years, a series of exhibitions devoted to the interpretation of art has tried to answer general questions puzzling to museum visitors. Working by trial and error, we discovered that a variety of objects—photostats, blow-ups, wire constructions, maps, montages, reproductions, original works of art, diagrams, shadow boxes, dioramas—could be used to reveal general principles of art. A book presents different problems, since much of the three-dimensional material used on walls cannot successfully be transferred to paper. Though the central idea of learning about art in terms of its own visual language is equally valid for exhibition and book, the printed page has the advantage of providing more space for a wider sequence of ideas which can be studied at greater leisure.

A book of this kind needs more than plates and text; its meaning depends on a continuous and related layout. I am deeply indebted to Gyorgy Kepes of the Massachusetts Institute of Technology for his design, where plates and text are revealingly correlated. He has done more than design; he has been a true collaborator, patiently working with me throughout. I am equally indebted to Daniel Catton Rich of the Art Institute of Chicago, who supported the idea from the beginning and helped immeasurably with valuable advice. In addition, I want to thank Rachael Brenner for typing the manuscript and generously assisting in its many revisions. To Albert L. Arenberg I am particularly indebted for an interest which made possible numerous visual experiments. Most of the comparative charts, diagrams and paintings are the work of Stanley Mitruk, whose intelligent co-operation has been of great help. L. Joan Daves of Harper & Brothers has worked closely with me and I am grateful for her understanding and enthusiasm. There are several colleagues at the Art Institute of Chicago whom I wish to thank: Petronel Lukens, Lester B. Bridaham, Peter J. Pollack for making available to me his excellent photographs, Kathleen Blackshear, who, in the series of drawings analyzing the form of a guitar, clarified the meaning of Cubism; Virginia Yarbro, Hazel C. MacAddam and Ruth E. Schoneman for their unfailing kindness in helping me find reproductions and photographs. To Pearl Moeller of the Museum of Modern Art and to Elizabeth E. Naramore of the Metropolitan Museum of Art I am grateful for advice and aid in assembling illustrations, and to Rosette Lowenstein I owe thanks for reading and criticizing early parts of my manuscript.

Nature Has Many Faces

Nature has many different faces. A few drops of water assume a multitude of shapes.

1 *Water on a Wooden Floor* Photograph by Gyorgy Kepes

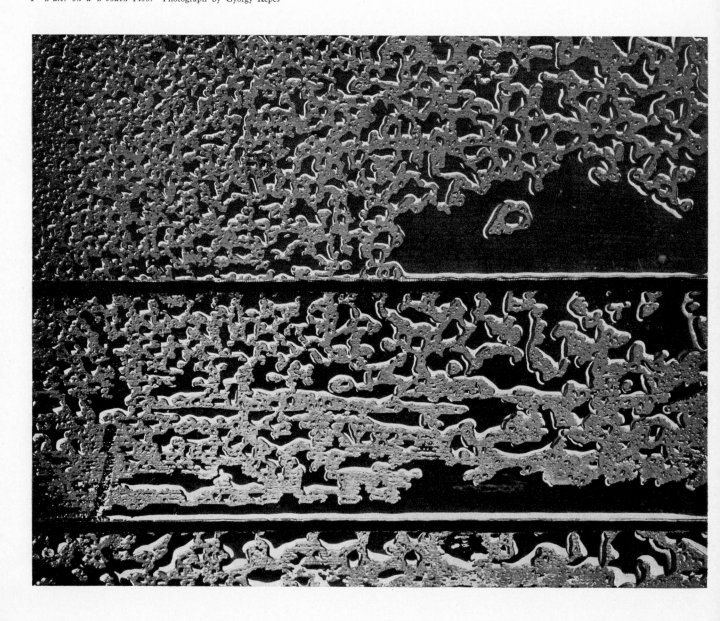

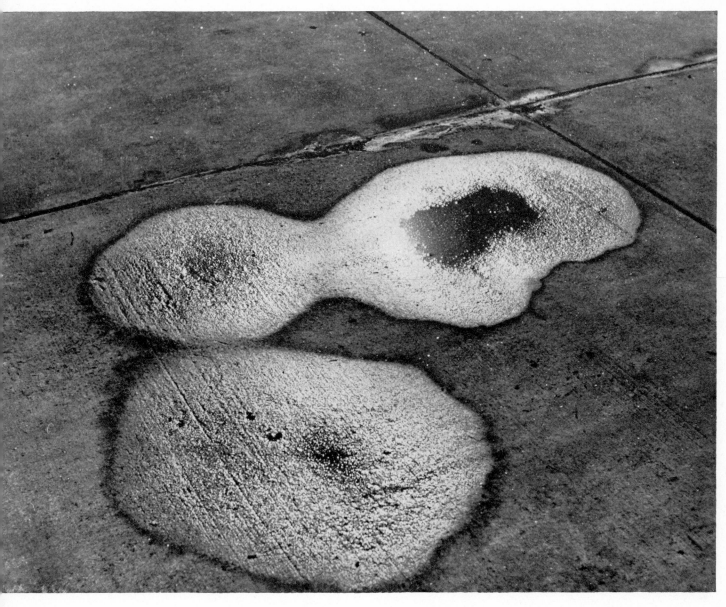

2 *Water on an Asphalt Pavement* Photograph by Gyorgy Kepes

Nature has many different faces. Man, through familiarity, has come to accept its changing aspects. Even a small child learns that a bare and linear winter tree will blossom in the summer and that time will make the young tree heavier. Light and climate bring other changes. Moonlight, sunlight, rain and reflection each in turn forms a new and different tree.

3 *Winter*
4 *Summer* Photographs Chicago Natural History Museum

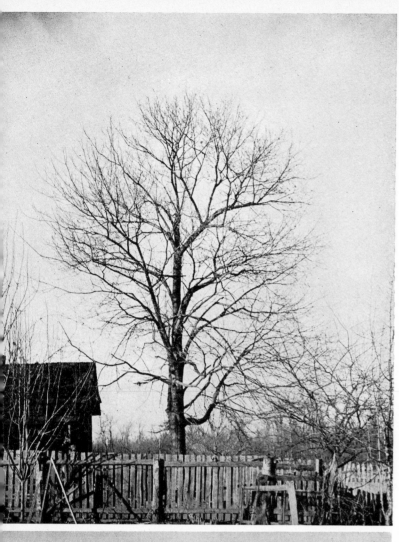

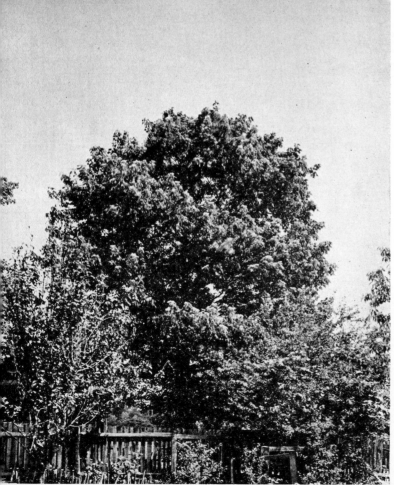

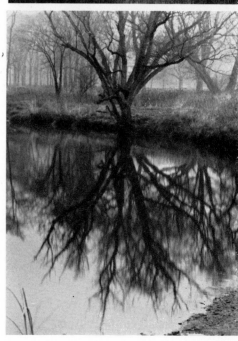

5
6 Photographs by Nishan Bichajian

5

There is also the observer, sensitized by his past, his surroundings and his personal needs. For him nature is never static; he may accept its astonishing variations with phlegmatic realism or he may question and marvel. In either case a plant like poison ivy, growing wild in a field, will look different when seen unexpectedly against a city building.

7 *Poison Ivy in the Field* Photograph Chicago Natural History Museum

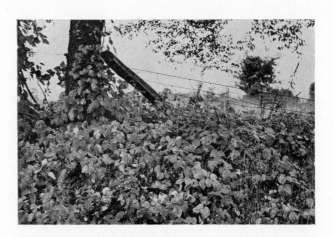

8 *Poison Ivy in the City* Photograph Chicago Natural History Museum

11 Photograph by Gyorgy Kepes

9
10 Photographs Chicago Natural History Museum

Nature seems to change as the observer changes his position. From a distance the eye sees a tree in its entirety, related to the surrounding landscape, but as one approaches more closely and stands under it one sees only a small enlarged section such as a branching trunk; later, in immediate proximity a little twig or piece of bark is isolated from the rest.

7

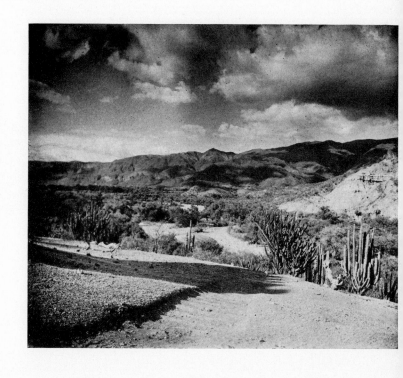

Cactus plants in the distance are dwarfed by the majesty of their desert and mountain surroundings, but when the observer moves toward them, the austere background dwindles and the plants dominate.

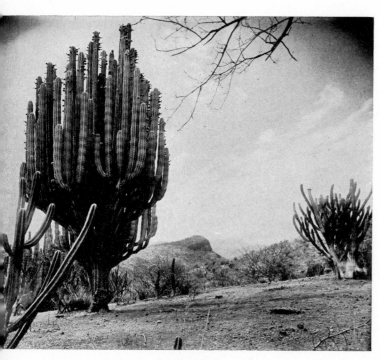

12, 13 Photographs by C. J. Chamberlin Courtesy Chicago Natural History Museum

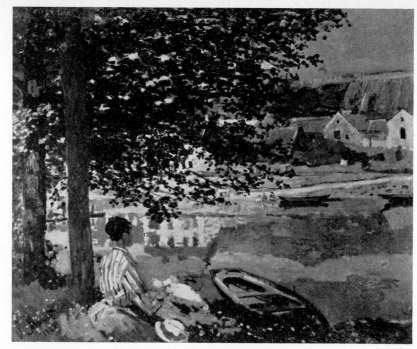

14 MONET *Argenteuil-Sur-Seine*
The Art Institute of Chicago

15 UNKNOWN ENGLISH ARTIST *Autumn*
The Art Institute of Chicago

There is no one reality, no uniform vision, for each man makes his own. When detached observation gives way to more personal demands and past experiences condition the eye, man is apt to see what he *needs* in nature. Then size, light and distance are less determinant factors than personal wants and associations. To one man the tree means shade and escape from the sun; to another a source of food; a third sees it as decoration in a sumptuous Italian garden, while for others it has only utility, providing firewood or stakes for the vineyard. Occasionally history makes it a symbol of death, hanging and defeat.

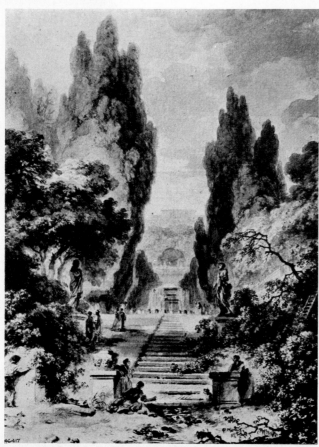

16 FRAGONARD *Tivoli: Stairway* Collection John M. Schiff

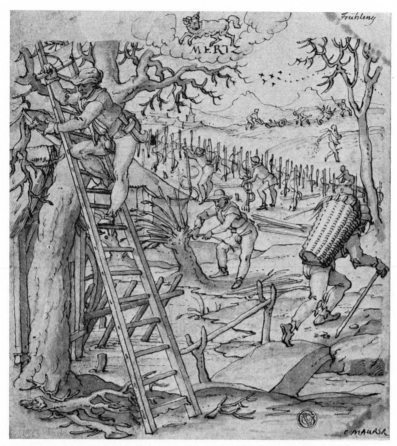

17 CHRISTOPH MAURER *Spring (March)* The Art Institute of Chicago

18 CALLOT *The Hanging* From "The Miseries of War"

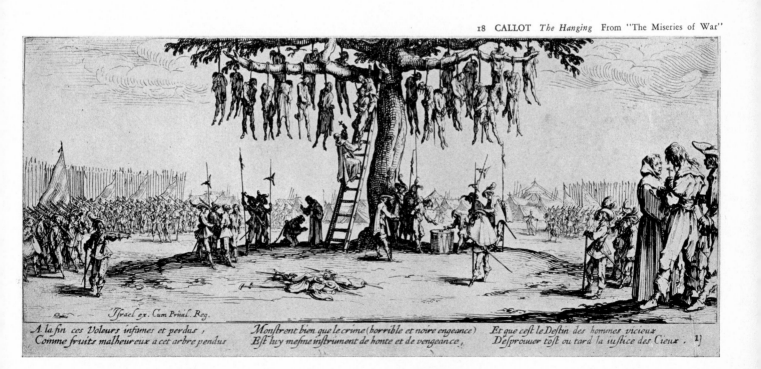

A la fin ces Voleurs infames et perdus , Monstrent bien que le crime (horrible et noire engeance) Et que c'est le Destin des hommes vicieux
Comme fruits malheureux a cet arbre pendus Est luy mesme instrument de honte et de vengeance, D'esprouuer tost ou tard la iustice des Cieux .

11

"Every word which is used to express a moral or intellectual fact, if traced to its root, is found to be borrowed from some material appearance. Right means straight, wrong means twisted; spirit primarily means wind; transgression, the crossing of a line; supercilious, the raising of the eyebrow. We say the heart to express emotion, the head to denote thought; and thought and emotion are words borrowed from sensible things, and now appropriated to spiritual nature." So Emerson defined symbolism. The "weeping" willow, with its drooping branches, is a symbol of sadness when its image is carved on the grave of a woman, but the oak, associated with strength, stands for courage and its leaves appropriately decorate the tomb of a sea captain.

19, 20 *Wellfleet Tombstones* Photographs by Gyorgy Kepes

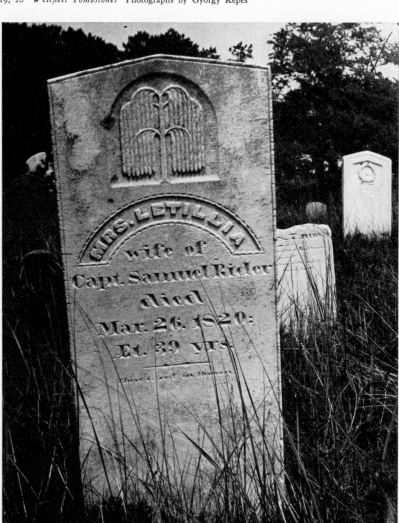

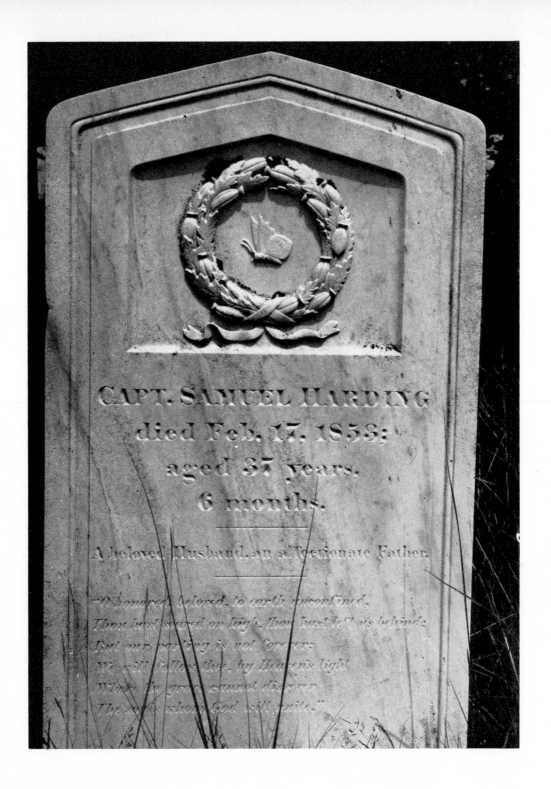

Art Has Many Faces

From century to century and year to year art, too, has shown many different faces. Witness the wide variety which time and place have produced in the concept of woman's form: the terse economy of a Cycladic stone carving, the fluent naturalism of Greek sculpture echoed by Della Robbia's Renaissance terra cotta, the linear and jagged "Virgin Enthroned," carved from wood in the Middle Ages, and the equally hieratic but far more sensuous African sculpture, also of wood. Later in our own century, Picasso's cubist painting, "Female Nude," recalls but in no way derives from the earlier Cycladic figure. Both are rigid, vertical, static and contained.

21 *Cycladic Sculpture*
The Metropolitan Museum of Art

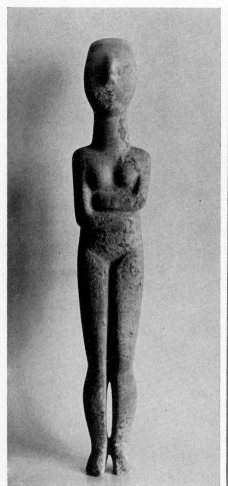

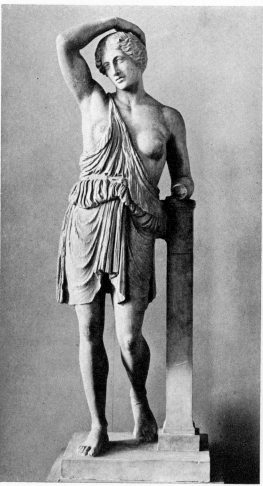

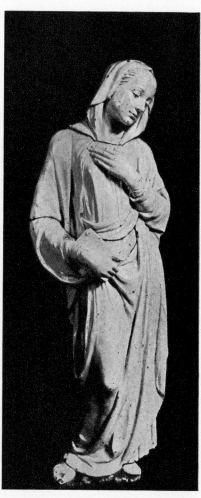

22 *Amazon (Greek)*
The Metropolitan Museum of Art

23 ANDREA DELLA ROBBIA *Annunciation*
(detail)

16

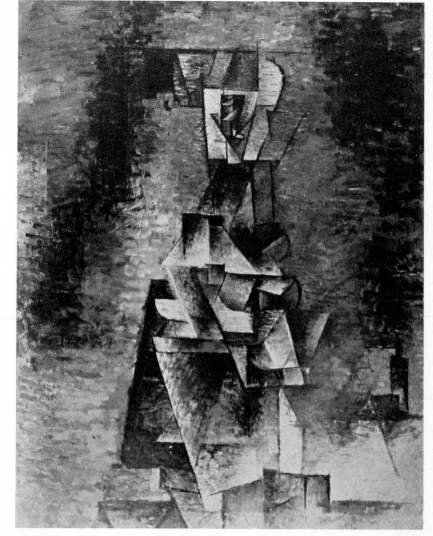

24 *Virgin Enthroned from Autun*
The Cloisters, The Metropolitan Museum of Art

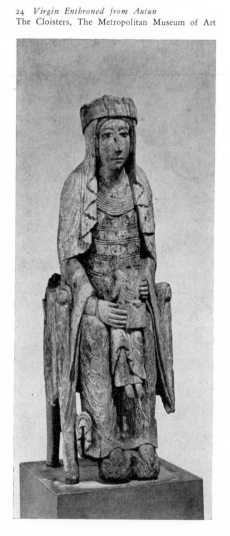

25 PICASSO *Female Nude*
Louise and Walter Arensberg Collection, Philadelphia Museum of Art

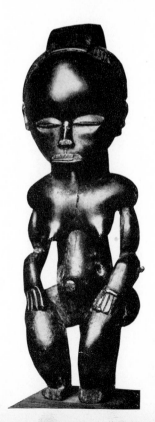

26 *African Wood Carving* Courtesy Éditions Albert Morancé

17

The Japanese artist, Harunobu, turned his seated woman into a rhythm of swirling lines more sophisticated than the Gothic engraving of a similar subject where crisp drapery reveals swelling forms. The same elegance which distinguishes Gérard's nineteenth-century portrait of Madame Récamier is found in an earlier Italian "Portrait of a Lady" by Parmigianino, but very different is Braque's full-blown "Nude Woman with Fruit," a twentieth-century figure of fertility. These many artists from different times and places, taking the same basic form, that of woman, as their point of departure, have produced extraordinary variations on this single theme.

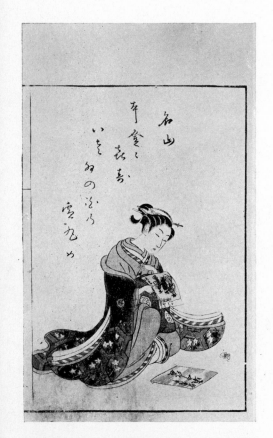

27 HARUNOBU *Meizan Examining a Print* The Art Institute of Chicago

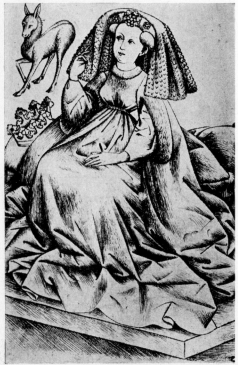

28 MASTER OF THE PLAYING CARDS *The Queen of Stags* Museum of Fine Arts, Boston

18

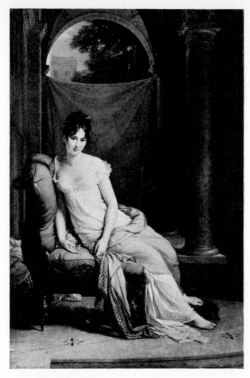

29 GÉRARD *Portrait of Madame Récamier* Musée Carnavalet, Paris

31 BRAQUE *Nude Woman with Fruit*
Chester Dale Loan Collection
The Art Institute of Chicago

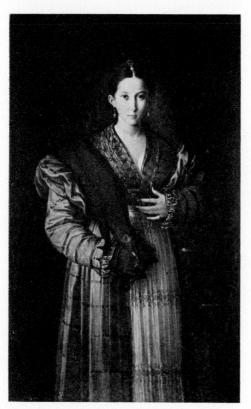

30 PARMIGIANINO *Portrait of a Lady*

The Royal Gallery, Naples

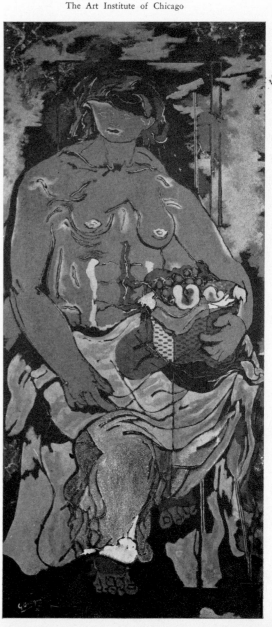

19

One need not move back and forth through history nor travel across the world to find art's different faces. Four artists living at the same time in the same place each see the same woman differently. Rouault, Matisse, Braque and Goerg, all working in France during the twentieth century, made portraits of the noted film star, Maria Lani. How freely they approached their subject, what liberties they took in terms of personal vision, how their associations conditioned their responses, are evident when the four portraits are compared with a photograph.

32 ROUAULT *Maria Lani* The Art Institute of Chicago

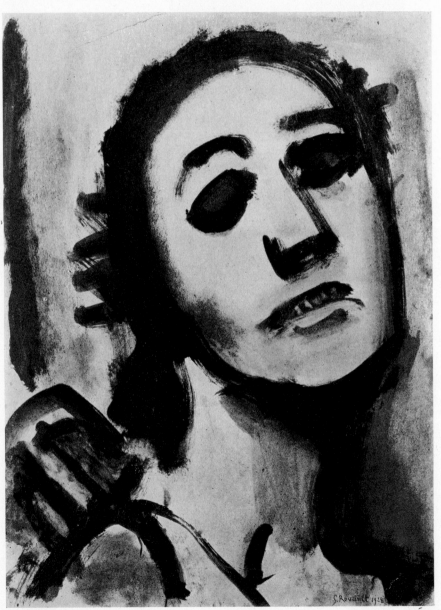

33 MATISSE *Maria Lani* Courtesy Éditions des Quatre Chemins

20

34 GOERG *Maria Lani* The Art Institute of Chicago

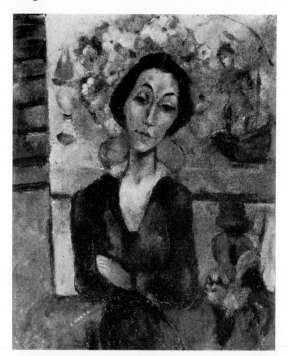

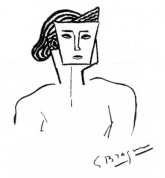

35 BRAQUE *Maria Lani*
Courtesy Éditions des Quatre Chemins

36 *Photograph of Maria Lani*
Courtesy Life © Time, Inc.

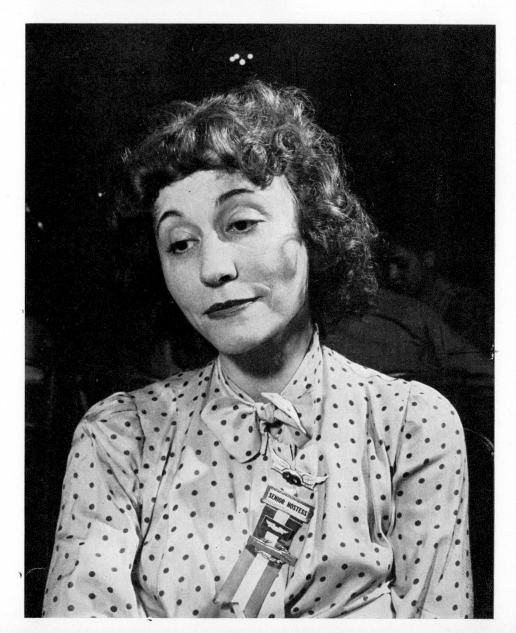

Consider only one artist, Van Gogh, who, within the brief span of less than five years, recorded his own image repeatedly and with implacable honesty. So quickly came growth, tragedy, confusion and retreat that the features in these four self-portraits change less than the facial expression. Though the subject remains the same, the artist in only a few years shows himself altered from doubting youth to lean and tortured maturity. This we can see without knowing his story.

37 VAN GOGH *Portrait of the Artist* (1886-1888) Collection V. W. van Gogh

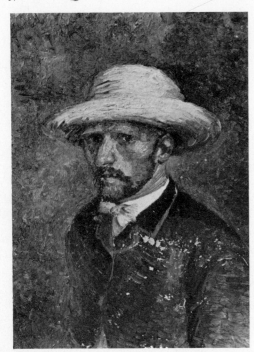

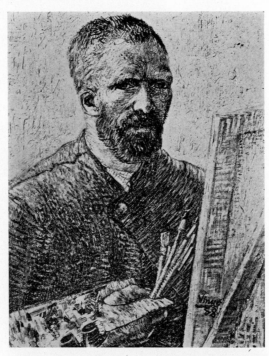

38 VAN GOGH *Portrait of the Artist* (1886-1888) Collection V. W. van Gogh

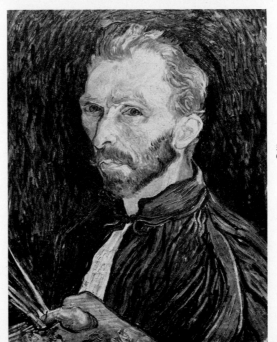

39 VAN GOGH *Portrait of the Artist* (1888)
Collection John Hay Whitney

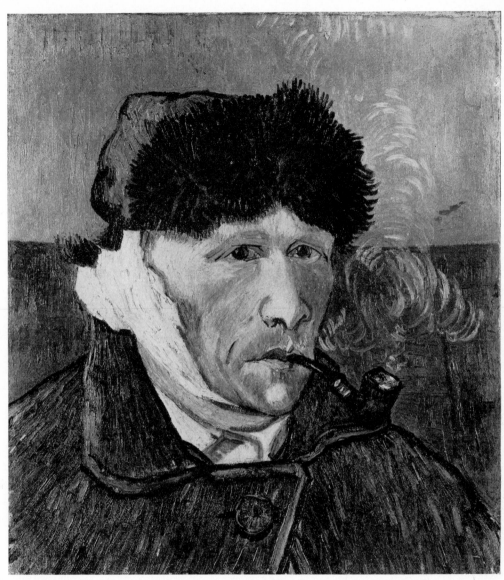

40 VAN GOGH *Portrait of the Artist with a Pipe* (1889) Collection Mr. and Mrs. Leigh B. Block

Where then does art differ from nature? These are not women we have seen, these are paintings, carvings, drawings of women; nor is this the face of Van Gogh but his painted image; for art, unlike nature, is both *made* and *seen* in terms of the human mind, differing from other more functional man-made objects in its ability to interpret and symbolize.

Man's individuality, the tools and materials which both restrict and free him, the magic, religious and social beliefs which grow out of his world and fashion his vision are forces motivating art's variations. But there are other aspects to consider; how each artist determines the structure of his work in terms of selection, arrangement, line, color, shape, light, space and texture. These common qualities have come to act as measures by which the observer sees and differentiates; they are part of an atavistic past which shaped even a cave man's drawings. To understand the physical world of nature and the outer forms of art, the observer unconsciously compares changing relationships in length, direction, extension, light, color and texture. Because man rarely sees the same object in the same way, artists take liberties with nature, altering and exaggerating as their needs and experience dictate. For them it is necessary to organize the outer world so that one immediate experience, implicit in a work of art, makes its point and delivers its message. Man's common desire for physical harmony, balance and order is so basic that it determines his art no less than other more personal motives.

The Artist Takes Liberties

The Artist Takes Liberties

In Selecting His Material

Through selection and elimination each artist takes from nature what he wants, rejects what he considers superfluous. An unknown Egyptian, working in the hardest of stone—basalt—carved a hawk but, when compared to the photograph of its soft and feathery prototype, one sees how consciously all unnecessary detail was avoided. This is the concise structure of a hawk, a universal rather than specific type. Controlled by hard stone, the artist, in exaggerating the bird's strength and power, understated its naturalistic appearance.

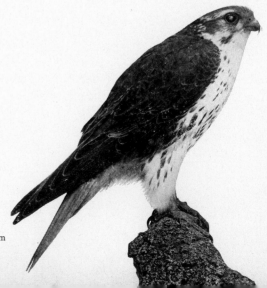

41 Photograph Chicago Natural History Museum

26

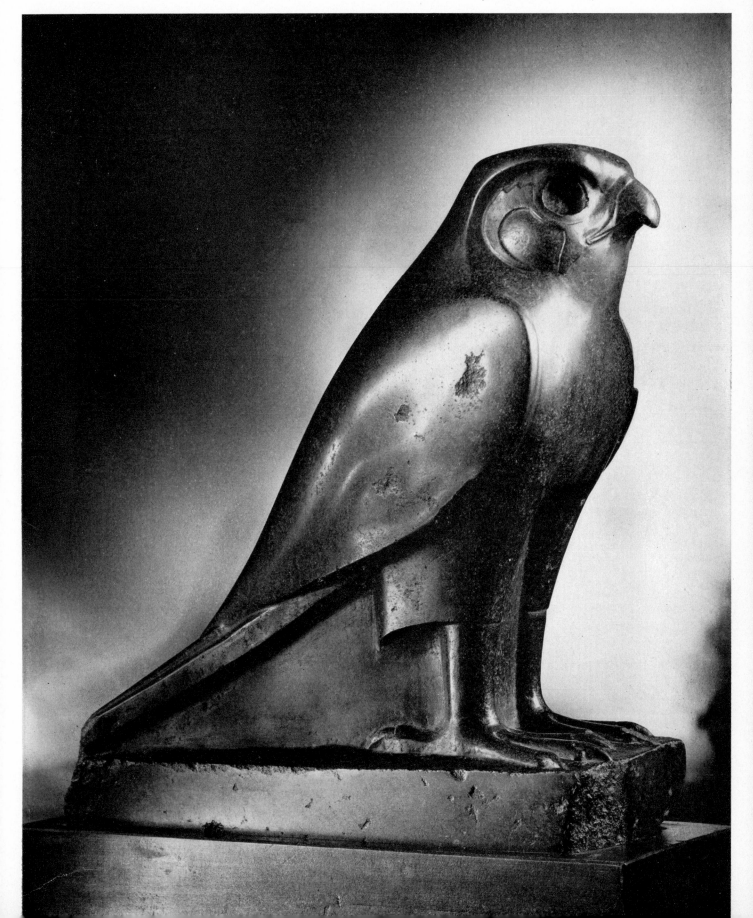

Cézanne, too, selected what he needed with a knowing eye. He condensed and solidified his work, eliminating all casual details which might obstruct essential relationships. He, like many other artists, wanted to strengthen the appearance of nature through concentration and simplification, or perhaps his intention was not so much to strengthen as to extract the full meaning from a natural scene by including only its most salient characteristics.

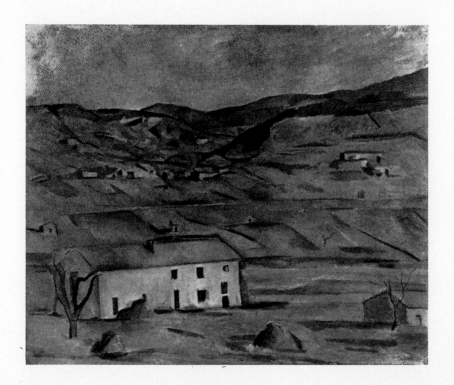

43 CÉZANNE *Environs de Gardanne* Courtesy University of California Press

44 Photograph by John Rewald of landscape Cézanne painted Courtesy University of California Press

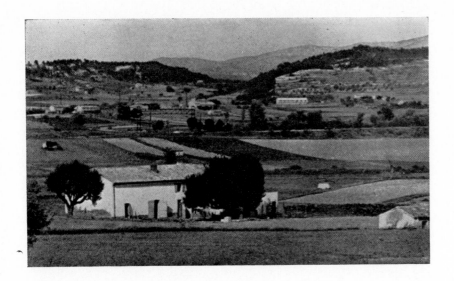

The dictionary defines the abstract as a "summary or an epitome." These six lithographs of a bull by Picasso show, step by step, how naturalism can be reduced to an absolute minimum. In the final version, form is "abstracted" into linear symbols and meaning is conveyed in the simplest way. Intermediate stages expose the animal's inner structure so that the last bull in the sequence is arrived at not alone through visual abstracting but also through a kind of organic reduction.

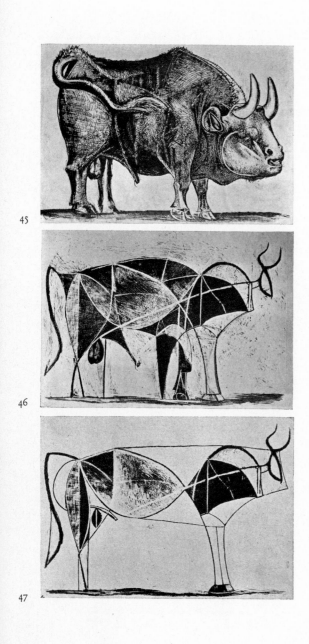

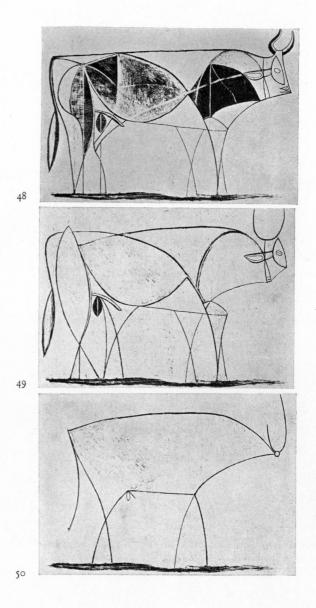

45-50 PICASSO *The Bull* Collection Mary Callery

30

The ultimate step was taken by Malevich when he painted "White on White." Here one faint white rectangle placed diagonally against a white background carries elimination to its supreme conclusion, since further simplification would lead to the original canvas. With proportions of geometric precision Malevich, using only rectangular shapes, hoped to bring order out of chaos and to introduce "pure feeling in the pictorial arts." This artist went beyond mere elimination of detail, for he entirely rejected the familiar world of nature.

51 MALEVICH *White on White* Museum of Modern Art

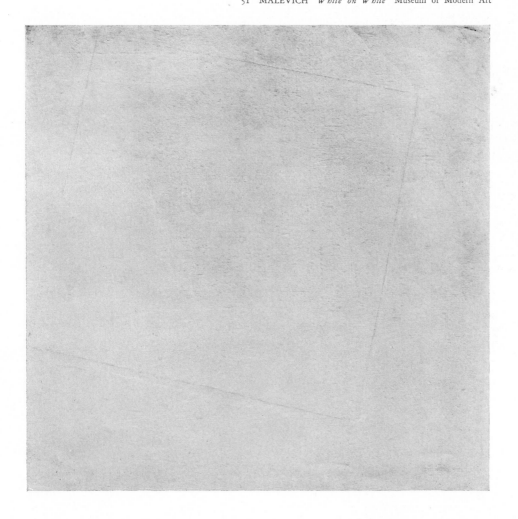

31

In Arranging His Material

After selecting his material, the artist is still faced by choices in arrangement. This still life by an unknown Spanish artist shows how astutely various forms have been related. Compare three altered versions with it and observe how the original work seems to have an inner order dependent on where and how each object has been placed. The fact that color is restricted to tonal variations of brown also helps to unify the painting. If every object is altered—the basket of nuts turned into a bucket, biscuits into a mug, mushrooms into lemons, grapes become a pepper and a phonograph record replaces a plate of shelled nuts—the painting still resembles the original. Here arrange-

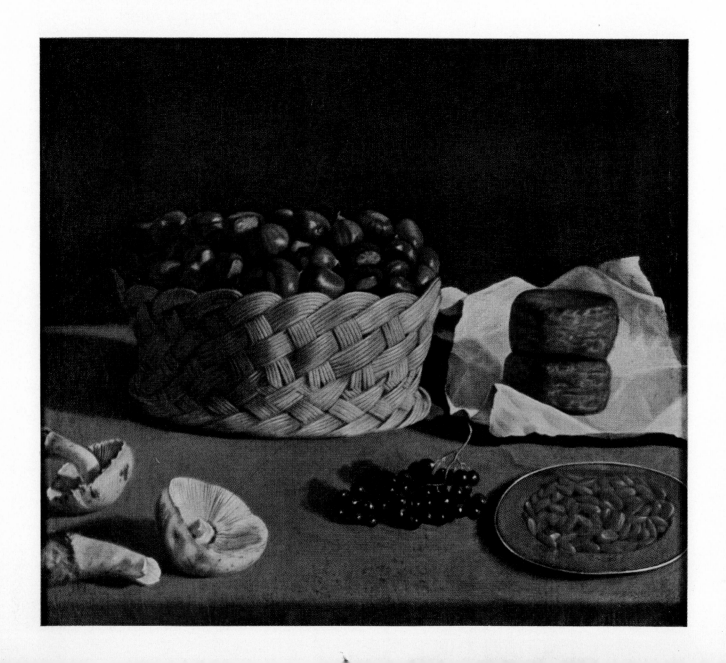

ment is stronger than subject. In the second altered version one element, the mushrooms, has been eliminated and the entire composition falls apart, because these light colored forms balance the light area around the biscuits and were intentionally included to complete the design. Further change occurs with the introduction of one discordant color. When the brown of the nuts is changed to bright pink, equilibrium is lost and the composition, originally so compact, serene and orderly, is destroyed by the obtrusion of one overstrong area.

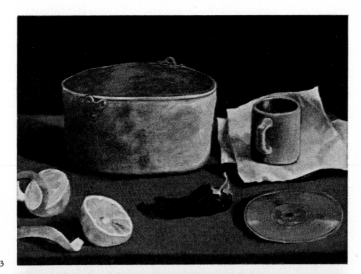

53

52 ZURBARÁN FOLLOWER *Chestnuts in a Basket*

The Art Institute of Chicago

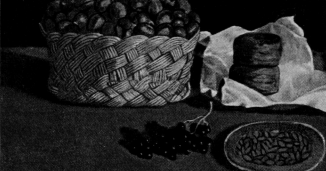

54

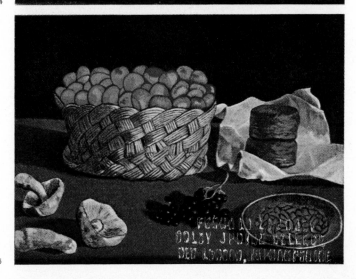

55

With Line

As each man writes differently, so calligraphy changes from country to country. In the Western world writing is a way of communicating verbal ideas, but in the Near East and the Orient it exceeds use and adds artistry to function. A Moor and a Chinese both make of their writing an aesthetic experience, for they study it in terms of fluency, variety and rhythm.

Each hand writes differently.
Each hand writes differently.
Each hand writes differently.
Each hand writes differently.

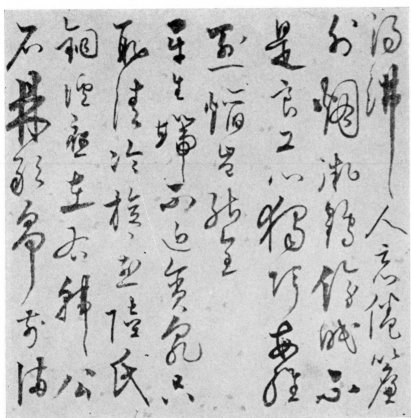

57 T'ANG YIN *Scroll Painting* The Art Institute of Chicago

58 Page from the Koran

The artist also alters and exaggerates line to emphasize or characterize. Toulouse-Lautrec made more than a caricature of "La Goulue"; his line with its brilliant variations, smooth, broken, thin, thick, staccato, incisive and soft, suggests the entire world of these sardonic dancing figures. When undifferentiated line is substituted, the lithograph loses much of its emphasis and meaning. In comparing the last two versions, where all detail and shading have been deleted, the full impact of Lautrec's line is evident, for the copy, drawn with unbroken, even line, seems anemic and thin. The sinews are gone, the bony anatomy, the daring thrusts and counterthrusts have mellowed into a flat suggestion of the original drawing.

59 TOULOUSE-LAUTREC *La Goulue* The Art Institute of Chicago

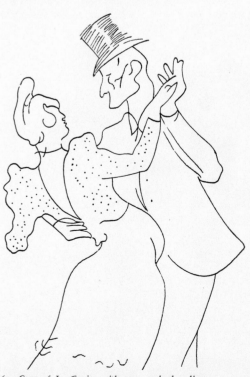

60 Copy of *La Goulue* with even, unbroken line

36

61 Original Lithograph, details and shading deleted

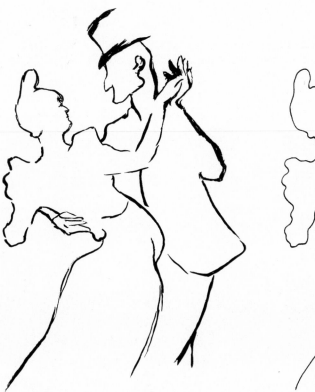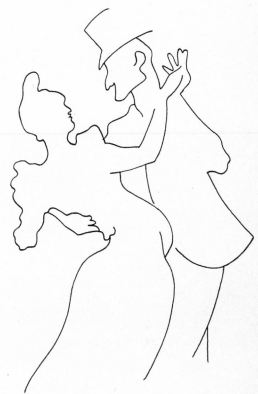

62 Copy of Illustration 61 with even, unbroken line

With Color

With color, even more than line, artists take liberties and improvise on nature, for even a green leaf differs for each man and the slightest change of light transforms it for the same eyes. Because there is no absolute, color in art becomes more than a naturalistic tool; it can be used expressively to describe emotions and moods. Vlaminck knew that fields were not blue, orange and bright red but when he painted "The Bridge at Chatou" he used these unconventional colors purposely to shock the observer into seeing the landscape in a new way. The bridge, boat, sky and field, though broadly painted, seem relatively naturalistic when seen in black and white reproduction. It is the electric color which transforms the scene, imbuing it with an excitement and tension which would have been impossible with more orthodox color.

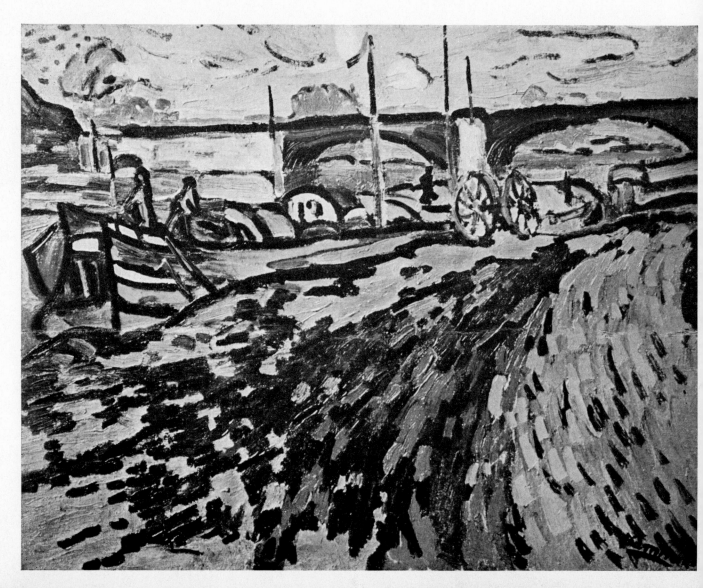

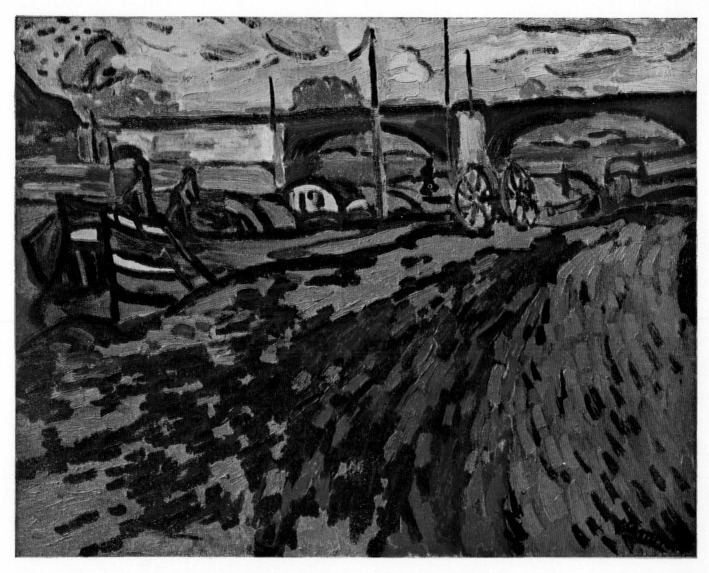

64 VLAMINCK *The Bridge at Chatou* Courtesy Wittenborn, Schultz, Inc.

VLAMINCK *The Bridge at Chatou* Courtesy Wittenborn, Schultz, Inc.

With Shape and Form

The artist alters shape and form at will. Deviations occur for a variety of reasons: to obtain better proportions, for emphasis, for compositional unity. Botticelli purposely elongated his figure to exaggerate its flowing rhythmic form. The body of the average woman measures six and one-half times the size of her head, but Botticelli increased this ratio to nine and one-half, thereby giving a more unbroken sweep to the sinuous contours of the body.

65 BOTTICELLI *Calumny* (detail) Uffizi, Florence

66

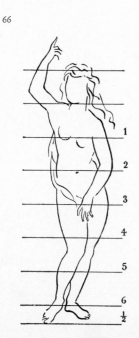

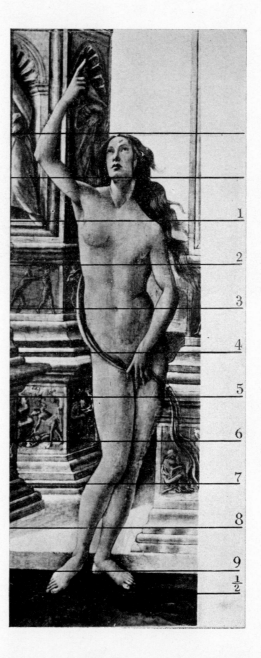

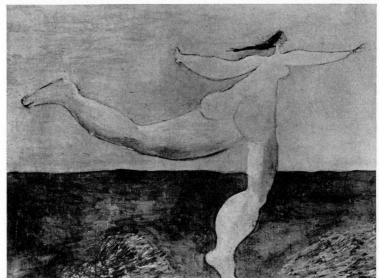

67 PICASSO *By the Sea* (detail) Collection Walter P. Chrysler

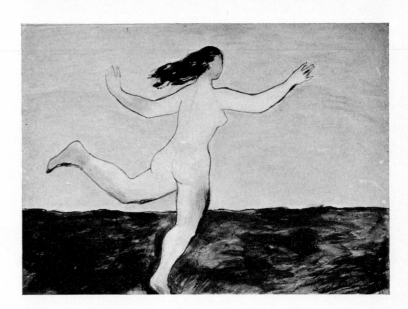

The running nude by Picasso, when seen with a more correctly proportioned copy, shows the artist's intention of emphasizing speed. By exaggerating legs and thighs, the upper part of the body, reduced and almost streamlined, is projected into the distance, a device which intensifies the suggestion of fleeing motion. Both figures are running but how much faster the one by Picasso!

Piero della Francesca integrated this composition by taking liberties with the waistlines of his figures, using belts as a continuous horizontal line in an otherwise predominantly vertical pattern. By slight deformations of shoulders, necks and drapery he fashioned an interlacing design, carrying the eye smoothly back, forth and into the painting.

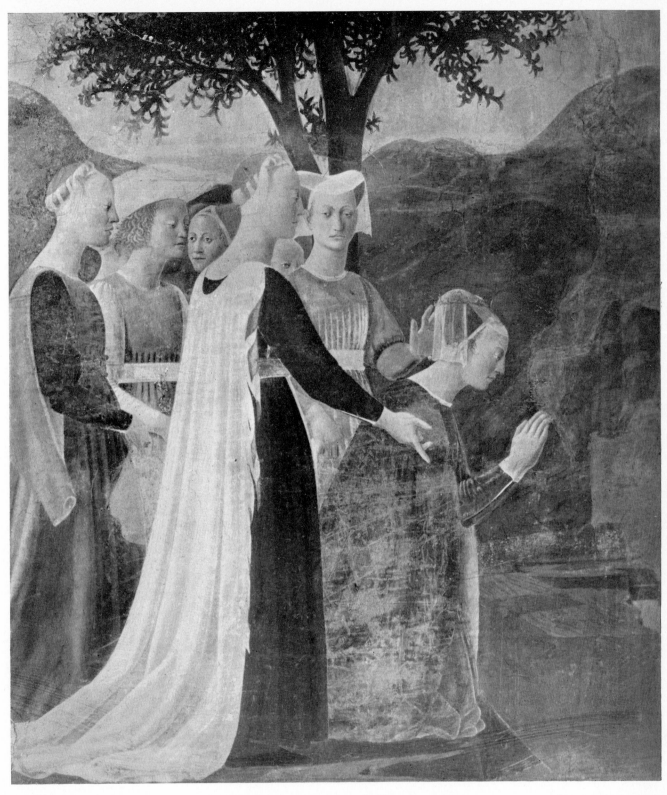

69 PIERO DELLA FRANCESCA *Recognition of the Tree by the Queen of Sheba* (detail) Arezzo, Italy

Artists have learned the ways of deformation from nature. Though a man's size and shape at a given time do not inherently change, they may *seem* to under different conditions; when he is viewed from above or below, from far or near, when he is seen twisting, stooping, turning, standing beside a large building or next to a small box. But these changes occur only in the eye of the observer. The artist, with more acute vision, takes advantage of this knowledge, for as Rodin said, "his eye, grafted on his heart, reads deeply into the bosom of nature." The following photographs show how vision is sometimes tricked and how shape and form can seem altered.

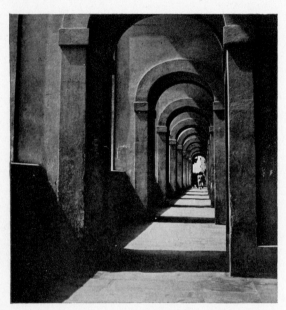

70 Photograph by Peter Pollack

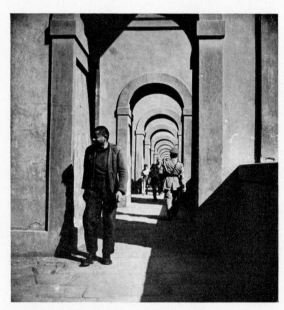

71 Photograph by Peter Pollack

The same arcade looks longer with small figures in the rear than with large ones in the foreground. Here scale and position play important roles, for in one photograph the eye is pulled back to the end of the arcade by dwarfed shapes, while in the other the architecture is dominated and depth is partly obliterated by large figures near the entrance.

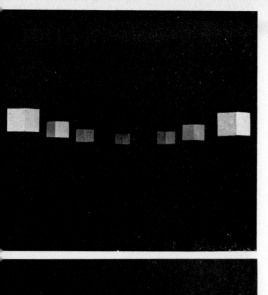

72 Planes with identical dimensions

73 Different-sized planes Study from the Visual Design Course, M.I.T.

Through skillful placement and by eliminating all points of reference, the photographer can make objects of the same size look different, and different-sized objects look the same. In the first photograph the cubes have identical dimensions, but as they recede from the camera they appear smaller. This visual phenomenon occurs when forms are removed from their surroundings and seen without comparative points of reference. The same, in reverse, happens in the second photograph where different-sized objects, again divorced from natural context, look alike in direct proportion to their distance from the camera.

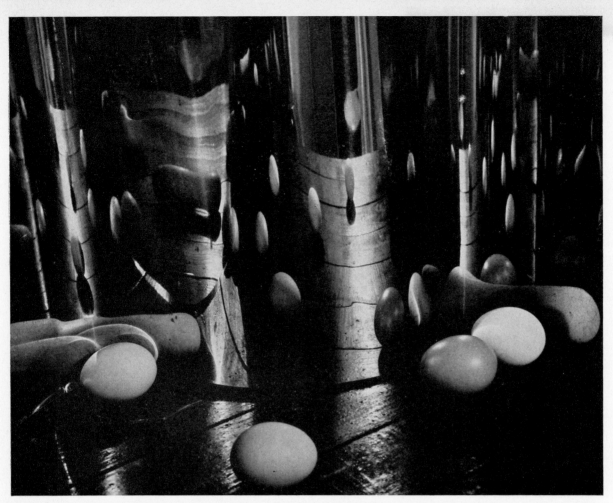

74 Photograph by Carlotta M. Corpron

With the simplest means this photographer, using only three eggs and reflecting mirrors, achieved a mirage of complicated forms. The eggs and the surface of the wooden table on which they rest are transformed into a multitude of new shapes, suggesting variations of the original ovoids. Who is to say which is the real, the only image of the egg?

A brief and spontaneous drawing, if photographed out of focus and then enlarged, is strangely changed. Instead of the initial delicacy, looming shapes emerge to suggest powerful forms because size and shape have been altered intentionally to produce new forms in a new relationship.

76 Photograph by Gyorgy Kepes

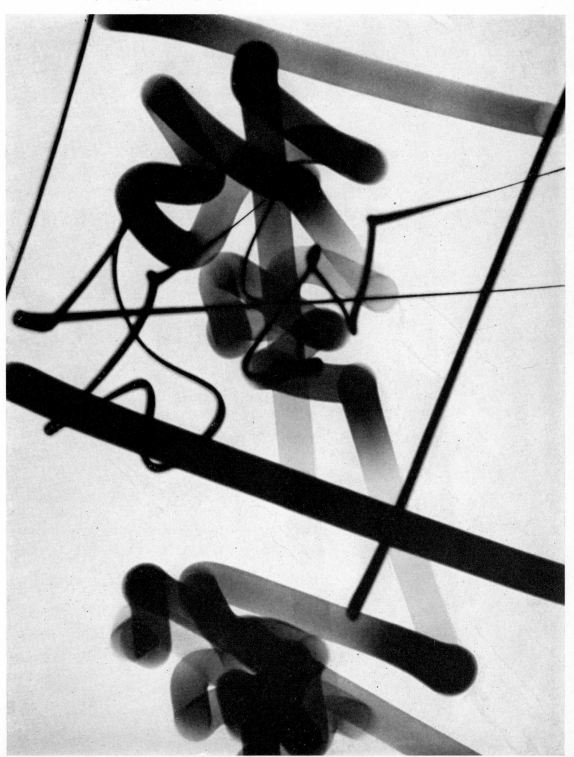

75 Drawing

The Artist Takes Liberties

With Light

Of all the elements which the artist uses, the most fleeting is light. He recognizes its momentary effects and controls them arbitrarily, for with light and shadow he can create mystery, clarity, strong forms, hazy contours and the most subtle nuances of surface.

An unknown Chinese artist harmonized his landscape with even, over-all, pervasive light. No hour of the day is suggested, no shadows, no source of illumination. But Gentileschi dramatized an otherwise serene version of the "Madonna and Child" by focusing strong light from the right. He exaggerated shadows to intensify crisp outlines and hard forms. In contrast, Carrière used a blurred half-light, enveloping his "Mother and Child" in an ambience of tender luminosity.

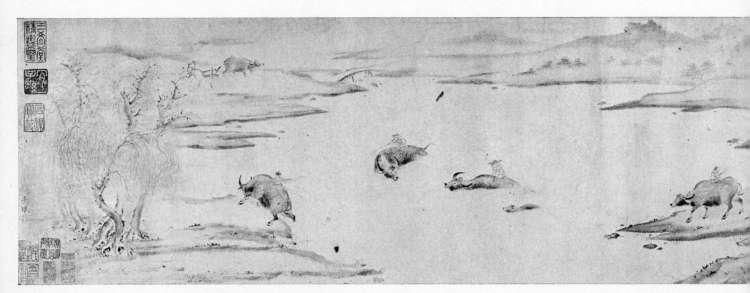

77 *The Buffalo Herd* (Chinese 14th Century) The Art Institute of Chicago

48

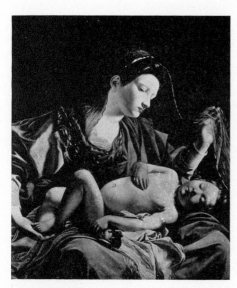

78 GENTILESCHI *Madonna and Child*

Collection Count Alessandro Contini Bonacossi

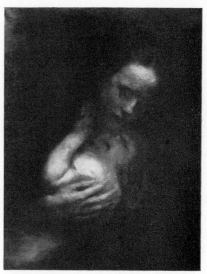

79 CARRIÈRE *Mother and Child*

John G. Johnson Collection, Philadelphia Museum of Art

Light the same bronze head by Rodin from opposite directions and its expression completely changes. By shifting the source of light from above to below, new hollows and protuberances emerge and features vary, now the forehead and cheek bones are accentuated, now the mouth and eyes.

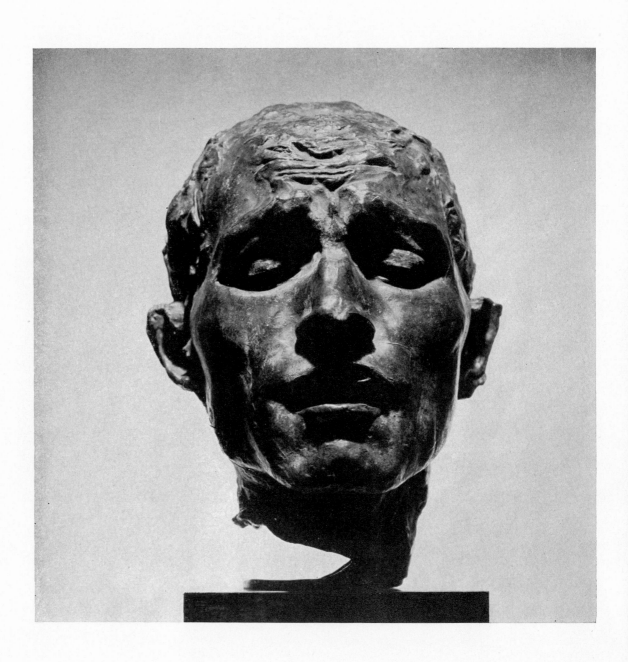

81 RODIN *Burgher of Calais* The Art Institute of Chicago

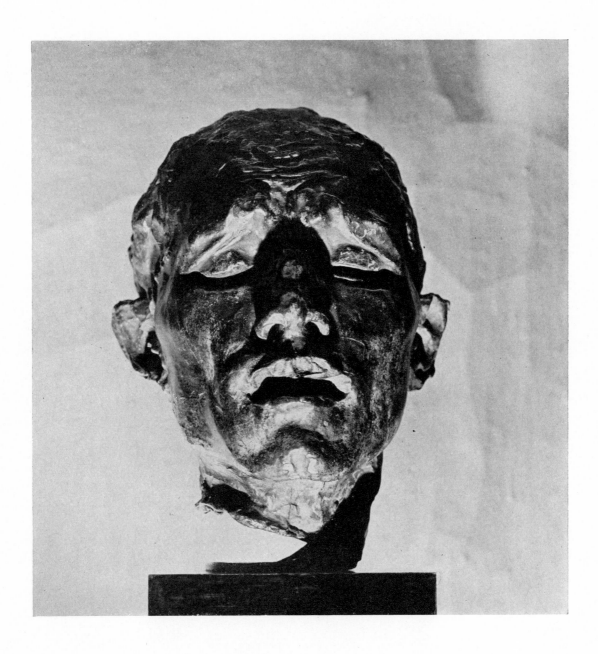

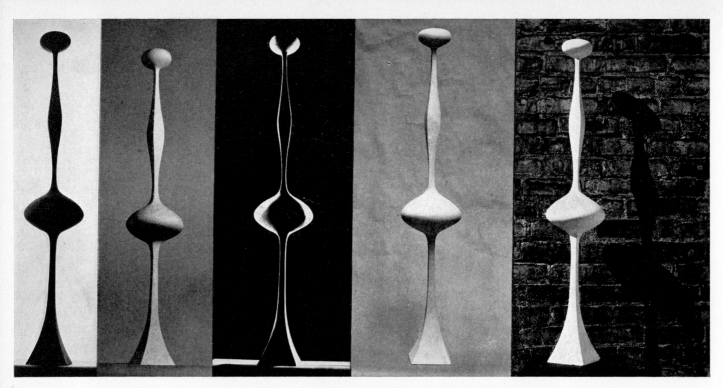

82 HUGO WEBER The same sculpture lighted in different ways Photographs by Robert Dale Hall

83 MONET *Vétheuil at Sunset* The Art Institute of Chicago

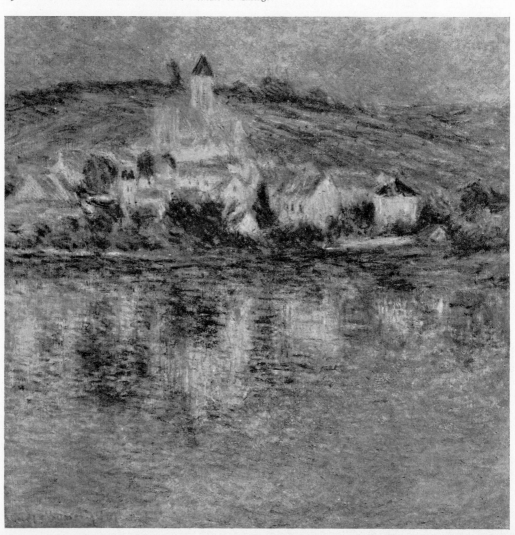

52

Because sculpture is three-dimensional, it is more affected by changes in natural light than painting where luminosity is depicted on the canvas and remains relatively fixed. The appearance of an abstract sculpture by Hugo Weber changes when it is lighted from different angles with different intensities and seen against backgrounds which absorb more or less light. But the painter cannot use light as an external element; he must himself recreate it on his canvas. Thus the Impressionist, Monet, painted the same landscape several times and, by changing the light in each picture, altered the scene. Two views of Vétheuil differ only in the hour they were painted—one at sunset, the other under a higher sun—but the shifting light caused changes.

84 MONET *Vétheuil* The Art Institute of Chicago

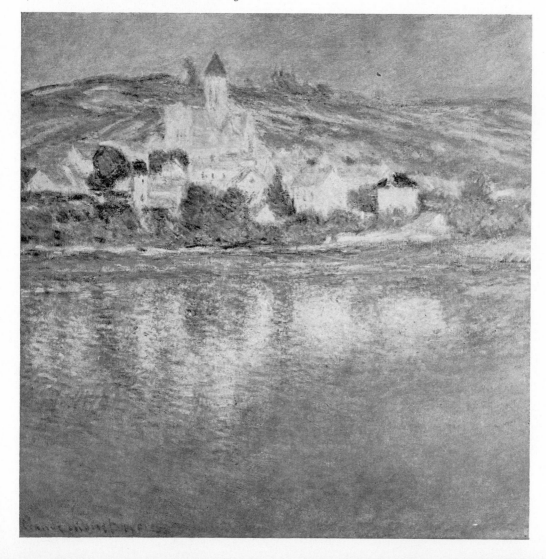

With Space

Some people think of space as an enclosed area marked off by boundaries; to others it is a mental concept defined for man's convenience with human measures. Space operates in all directions and surrounds the observer everywhere, differing from distance which is conceived in terms of depth alone. Space has no limits, no formal barriers and is so subtly attuned to visual variations that every step man takes, every form he sees, every tone or color he perceives changes his sense of space. In the twentieth century we continually relate space to time, because the accelerated speed of our period necessitates constant visual and psychological adjustments. Hurtling through space in an airplane, receiving a cabled message from across the ocean, watching a television program, where immediacy in time and space is carried to its ultimate extreme, are all experiences which demand new attitudes and understanding.

In early Italian painting a device still popular today was sometimes used to depict space on a flat surface. Because nearby objects tend to obliterate parts of those further away, this fourteenth-century artist placed his oxen in overlapping positions to suggest depth. But this is only an illusion, for when intersection lines are removed from a simple drawing, recession and the suggestion of space disappear, resulting in a flat design.

86

87

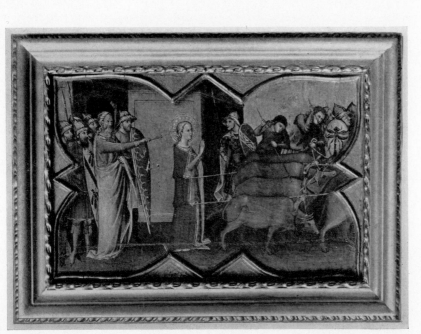

85 CHRISTIANO *St. Lucy Resisting Efforts to Move Her* The Metropolitan Museum of Art

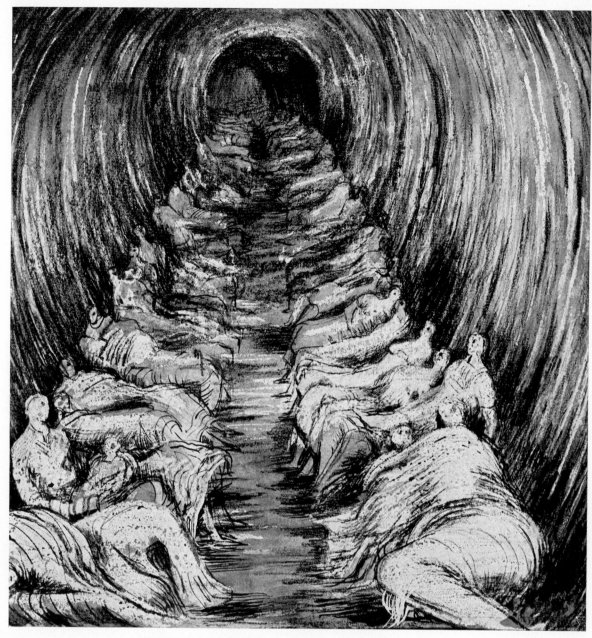

88 MOORE *Tube Shelter Perspective* Collection Eric C. Gregory

Henry Moore's water color, "Tube Shelter Perspective," exploits the device of overlapping forms to the fullest, using a succession of superimposed figures to carry the eye back into an almost endless depth.

A sense of space is intensified by the juxtaposition of forms or lines in the foreground of a picture. These act as points of reference to be looked through or beyond and produce comparative measures for estimating the space and distance between objects. Reginald Marsh has made the towers of Manhattan seem much further away because they are viewed through the quickly sketched lines of a bridge. A photographer used the same method by placing his camera before a barred window, and when Cézanne named his water color "Houses *Through* the Trees" he gave ample proof of his intention. He even accentuated the process of looking "through" by making the trees transparent, so one not only looks between but through them to evaluate better the relative distance of the houses. A photograph of trees in South Carolina, though lacking Cézanne's economy of detail, gives a similar feeling. Again by looking through and beyond layers of dripping foliage, a scale of reference is established for judging recession and depth. The eye, carried back in many different directions by repeated overlays, breaks through the flat rectangular surface of the photograph.

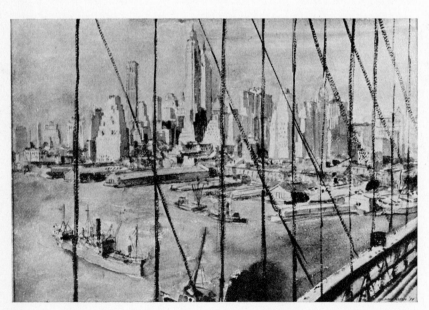

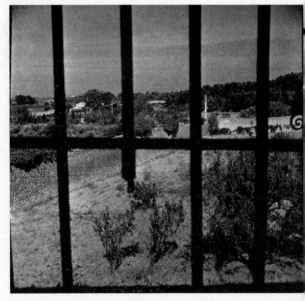

89 MARSH *From the Bridge* Courtesy Rehn Galleries

90 Photograph by Peter Pollack

 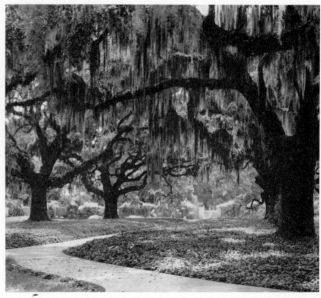

91 CÉZANNE *Houses Through the Trees*
Collection J. and H. Bernheim-Jeune

92 Brookgreen Gardens, South Carolina

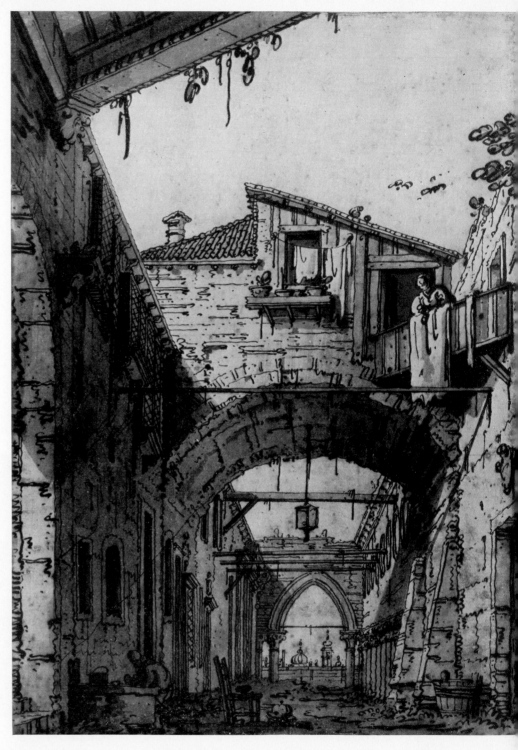

93 CANALETTO *Ruins of a Courtyard* The Art Institute of Chicago

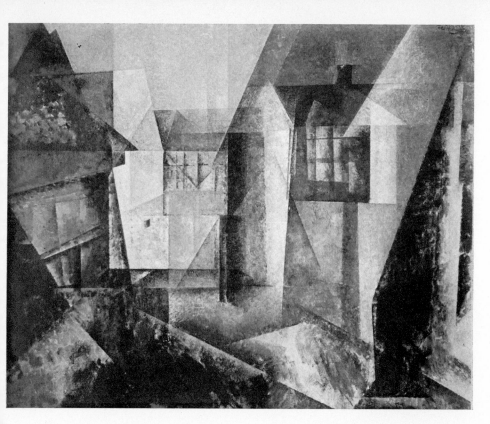

94 FEININGER *Village Street*
Collection the Artist

In the past, artists tended to emphasize one direction in space, but today they are preoccupied with multiple directions. The earlier painters worked out elaborate rules of perspective in terms of simple recession, recognizing that objects seem to diminish and lines seem to converge in the distance. The modern artist tries to open his canvas in many directions, not alone in depth. He exploits every possibility, directing the eye up, down, back, across and diagonally into space, using any number of starting points. If Canaletto's drawing, with its carefully contained perspective, is compared to the painting, "Village Street," by Feininger a different use of eye levels is immediately evident. Canaletto presupposed the observer's position to be constant and directly in front of his drawing, whereas Feininger, with multiple eye levels, forces his observer to look into the canvas from conflicting angles. For those who live in present-day cities, where streetcars, elevated trains, subways and airplanes all operate in different directions on different levels at the same time, space can become a complicated experience.

95 DALI *The Font*
Collection Mr. and Mrs. A. Reynolds Morse

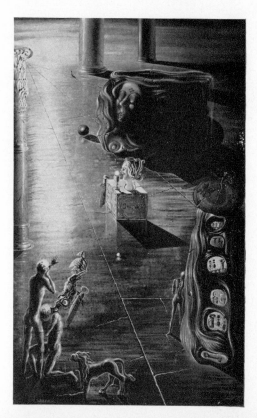

Dali, with distorted scale and depth, created this frightening, dreamlike scene. In order to suggest a psychological state of mind he broke all the rules of perspective, making lines converge too soon and the size of his figures independent of normal proportions. Sensations of fear and uneasiness are produced, as Dali intended, by irrational content and spacial inventions, both borrowed from the unconscious world of dreams.

With Texture

In art texture is sometimes real, sometimes simulated. For painting it varies with the application of brush stroke as it does for sculpture with surface modeling or carving. But texture implies more than mere surface handling; a work of art can suggest textural variety without an appreciable change in surface.

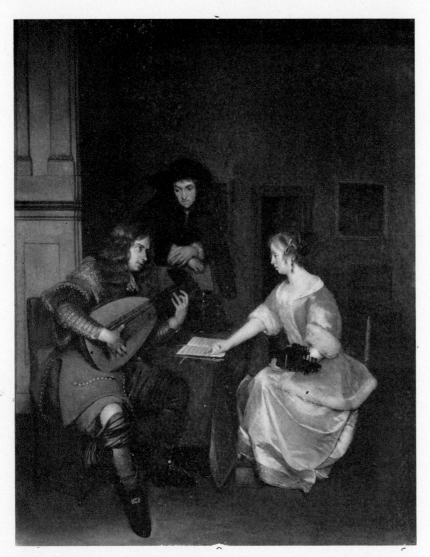

96 TER BORCH *The Music Lesson* Hermitage, Leningrad

Materials like satin, fur, braid and glass were expertly simulated in a painting by Ter Borch, where brush strokes are so evenly applied that the canvas appears glassy. In contrast, Van Gogh's thick pigment in "A Field under a Stormy Sky" shows the frank imprint of his tools, probably brush and palette knife, and suggests, with its rough texture, not real fields and clouds but the turbulent emotions felt by the artist when he painted the scene.

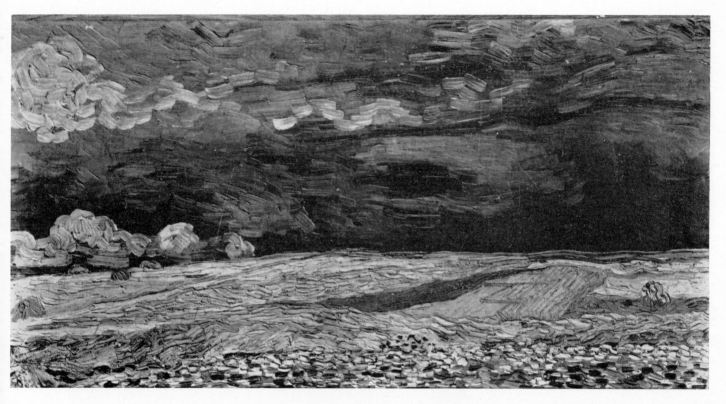

97 VAN GOGH *A Field Under a Stormy Sky* Collection V. W. van Gogh

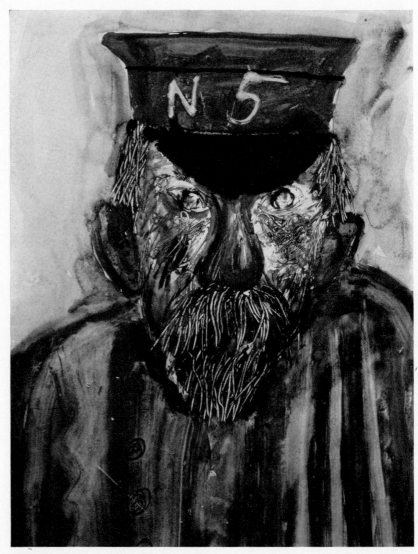

98 DIX *The Porter* Collection J. B. Neumann

Otto Dix, with incised brush strokes and harassed surface, made this portrait express less his own state of mind and more that of the subject, a bleary, bedraggled porter. In exaggerating every surface nuance with more than photographic realism Ivan Le Lorraine Albright, like Ter Borch, used smooth pigment, but his purpose was different. Ter Borch wanted to depict the textures of varied materials, whereas Albright wanted varied textures to intensify the psychological meaning of his painting. His eroded and scarred door is the very essence of death, and the title, "That Which I Should Have Done I Did Not Do," assumes more meaning when associated with the finality of decay.

99 ALBRIGHT *That Which I Should Have Done I Did Not Do* Collection the Artist

100 Detail of Illustration 99

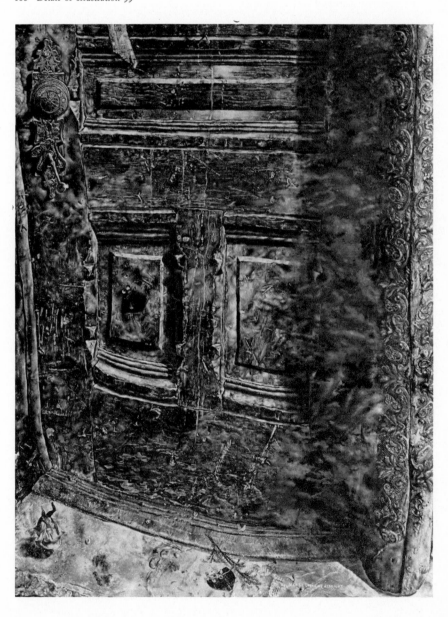

63

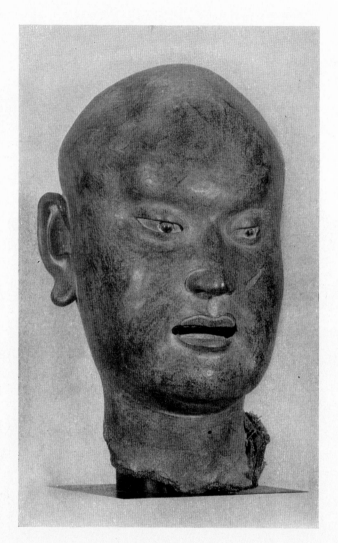

101 *Head of a Lohan* (Chinese) The Art Institute of Chicago

In sculpture, too, texture is sometimes used for emotional definition. How much more serene is the smooth head of a Lohan than Epstein's rougher bronze one, though both are individualized portraits. A steel figure by Theodore Roszak, twisted into textured and perforated forms, contrasts with the calm contours of the Chinese head and, with its restless and jagged angles, makes even the Epstein sculpture seem quiet.

64

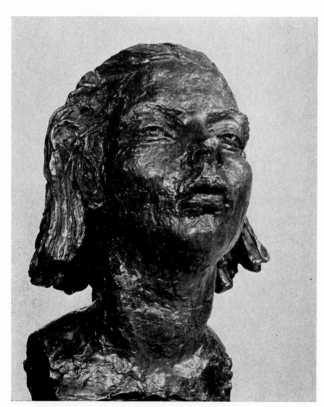

102 EPSTEIN *Head of a Girl*
Collection Howard Young

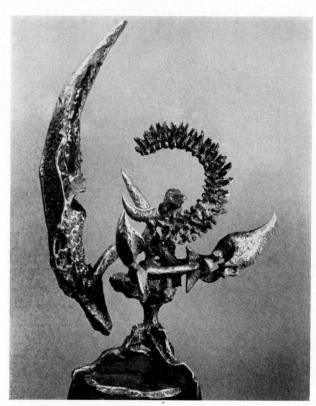

103 ROSZAK *Thorn-Blossom*
Whitney Museum of American Art

104 MIRÓ *Woman Combing Her Hair* Collection Mr. and Mrs. Joseph S. Stein

Sometimes it is not alone application of pigment or surface modeling which causes textural variety; the materials used are equally important. This painting by Joan Miró shows how the texture of burlap was incorporated as part of the design, how the artist used, not a simulated burlap, but the real material as the surface for his work. Braque amplifies the same idea by combining various kinds of paper and corrugated cardboard in a strongly textured composition where variety results from real rather than suggested surfaces. This technique opened new possibilities as it broke down the conventional barriers which limited painting to single backgrounds of paper, canvas or wood panel.

105 BRAQUE *Musical Forms* Louise and Walter Arensberg Collection, Philadelphia Museum of Art

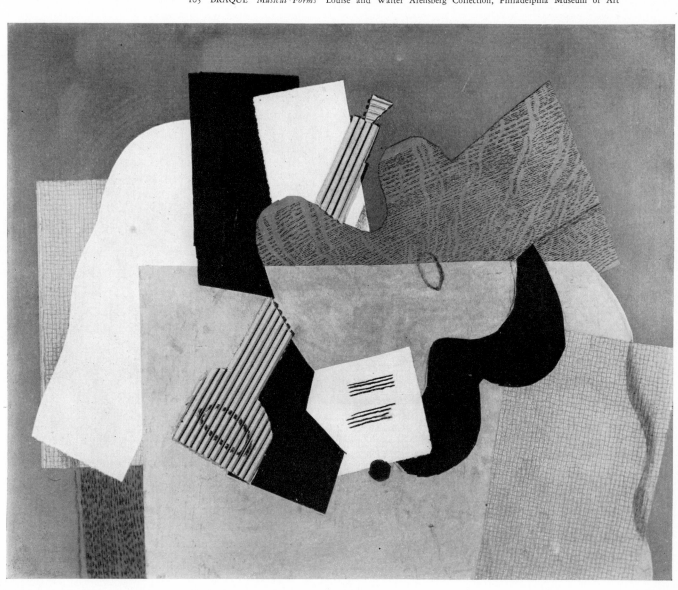

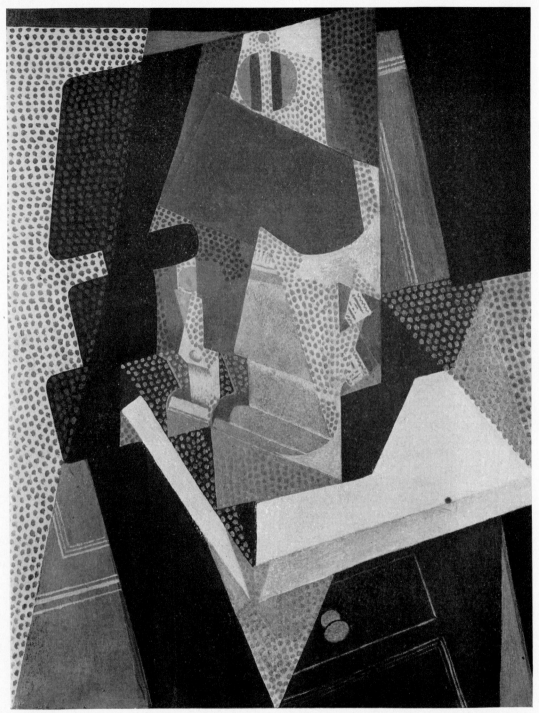

106 GRIS *The Lamp*
Louise and Walter Arensberg Collection, Philadelphia Museum of Art

Artists have manipulated texture for decorative as well as emotional reasons. Juan Gris in his cubist painting, "The Lamp," chose a dotted surface, extended and moved it around at will until he made an arbitrary composition to his own liking.

Nature, too, is seen in terms of texture. Two shells isolated against a rough cloth show how dramatic surface irregularities and convolutions can become.

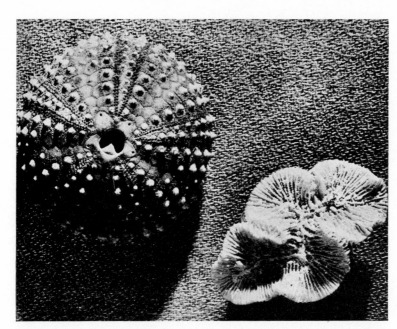

107 Photograph by Franz Berko

To think of art in terms of any one aspect is misleading, be it *selection, arrangement, line, color, shape, light, space* or *texture*, for these are interacting elements. We have seen how size affects distance, how color changes form, how selective light can be. Separating boundaries do not exist because it is from the interrelationship of all these qualities that art evolves.

The limitations of his materials and the nature of his tools both restrict and shape the artist's work. Water colors dry quickly and, as a rule, are damaged by repainting, so they must be executed more swiftly than oil paintings, which rarely achieve the same transparency but can be successfully corrected and painted over. Certain fresco techniques exert even greater time pressure, for a given section of wall, after special preparation, must be painted in one session while the plaster is wet. This necessitates careful advance planning and tends to discourage spontaneity.

108 John Marin painting with water color Photograph by Alfred Stieglitz

109 Orozco painting a fresco Photograph Museum of Modern Art

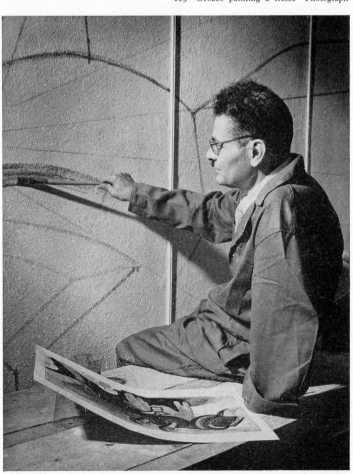

110 Photograph by Charles Lichtenstein

111 David Smith carving stone

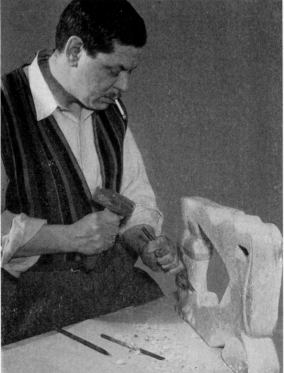

112 Inking a lithograph stone

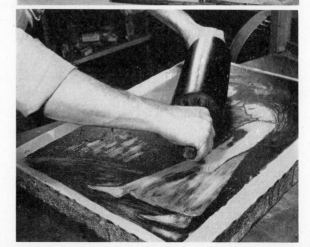

To model and manipulate soft clay is a far less final process than to carve stone because the clay, if kept damp, can be revised frequently but stone, when once cut, is less amenable to change. In the graphic arts each tool presents a different problem; the lithographer, drawing with crayon or brush on a smooth stone surface, achieves more immediacy than the etcher who cuts into metal with acid, a less spontaneous process. Canvas, paper, composition board, plaster, wood, stone, metal and plastic, each characterized by different properties, affect the artist no less than the tool he uses, be it brush, pen, or chisel.

113 Using the etching needle
Photograph by Roscoe Carver

73

Limitation of material need not always prevent personal expression. If the artist restricts himself only to line on paper he still chooses from a surprising assortment of techniques. Two portraits of men, one by Van Dyck and the other by Kirchner, show how characterization can in part depend on method and material. To emphasize an aristocratic head Van Dyck used a technique adapted to the delicacy he needed. He etched his subject on a metal plate where acid ate into a surface prepared to reject ink. Thus only thin lines bitten by the acid appear in the print. Kirchner, with opposite purpose, cut heavy slashes directly into a block of wood, making a powerful portrait with incisions too deep for ink. Here definition results from heavy unprinted lines of white against the inked areas. Acid and metal, knife and wood, etching or woodcut—each makes a different kind of line and a different kind of expression. So also with engravings and lithographs. Martin Schongauer's hard, tight contours result from drawing on a resistant metal surface with sharp instruments, while the swirls of pliant line Edvard Munch produced were drawn on stone with greasy crayon.

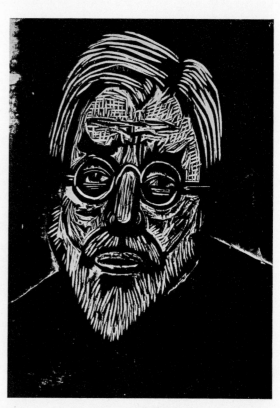

114 VAN DYCK *Frans Snyders*

115 KIRCHNER *Portrait of Boshart*

116 SCHONGAUER *St. Lawrence*

117 MUNCH *The Lovers*

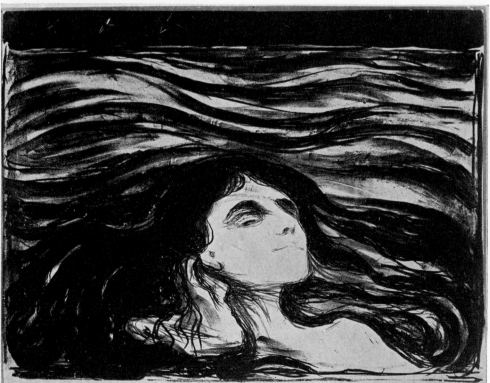

Because oil paint is thick and opaque, Rembrandt was able to model a head of Saint Matthew from heavy daubs of superimposed pigment, giving the face substantial weight and substance. On the other hand, John Marin exploited the transparency of water color, allowing white paper to shine through thin washes of paint, filling his tenuous landscape with light and atmosphere.

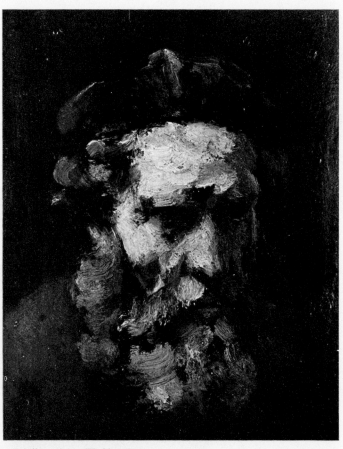

118 REMBRANDT *Head of St. Matthew* National Gallery of Art, Washington

119　MARIN　*Landscape in Maine*　The Art Institute of Chicago

With sculpture, too, each material has different properties, requires different tools and is better adapted to certain forms of expression than to others. The head of Gudea's son, more compact than Verrocchio's head of David, recalls in its austerity the original block of stone from which it was carved. But the ingratiating "David" with its fluent curves is better expressed by a more fluid material, in this case bronze. The same is true of bas-relief. Alessandro Vittoria's "Annunciation" has a mobility suggesting the molten metal from which it was cast while a more contained Egyptian frieze is related to the rigidity of stone.

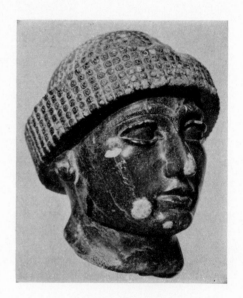

120 *Head of the Son of Gudea* The Metropolitan Museum of Art

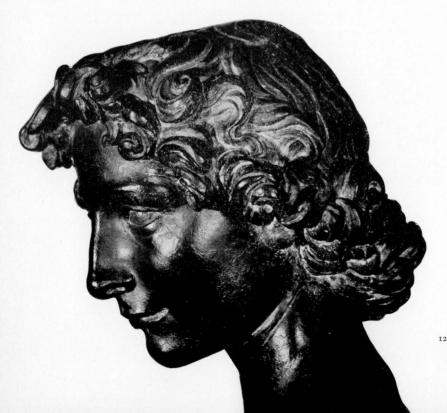

121 VERROCCHIO *David* (detail) Bargello, Florence

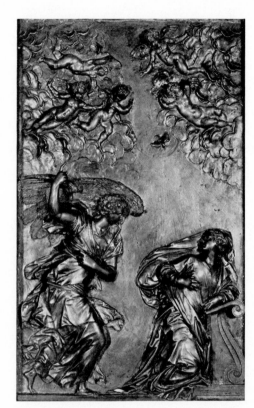

122 VITTORIA *Annunciation with Angels* The Art Institute of Chicago

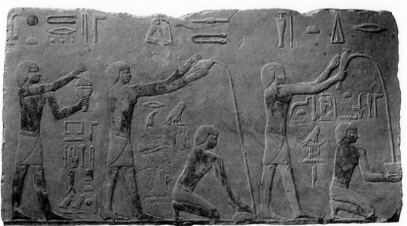

123 Egyptian frieze

Characteristics of Materials

Hard or soft, light or heavy, transparent or opaque, shiny or dull, three-dimensional or flat, surrounded or free, these are the chief characteristics which differentiate materials.

124 Woodcarvings from New Guinea Photograph Chicago Natural History Museum

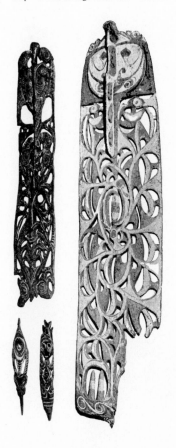

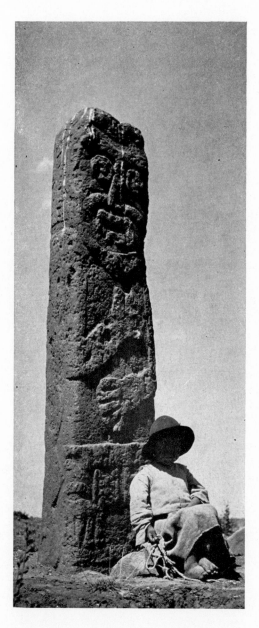

125 Stele from South America
Courtesy Three Lions Inc.

Hard or Soft

Perforated and lacelike carvings from the South Seas lend themselves readily to soft material like wood, but in the monumental stele from South America decorative details too difficult to carve in stone were avoided and only the basic forms were included.

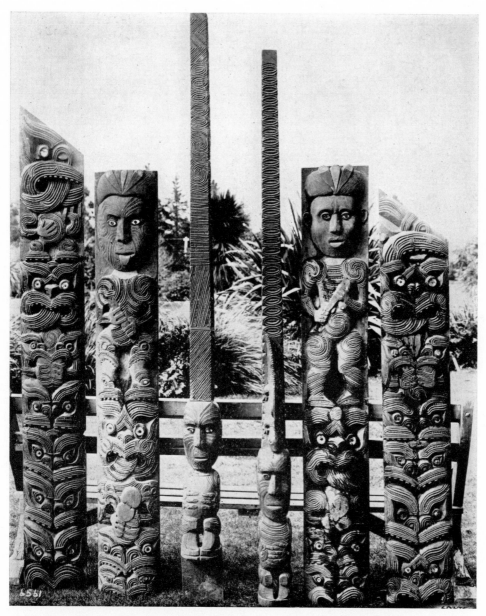

126 Woodcarvings from a Maori house Photograph The American Museum of Natural History

Heavy or Light

In prehistoric Stonehenge and ancient Egypt huge blocks of masonry weighted the architecture, but the light soaring lines of today result from modern steel construction. Now only the metal skeleton need remain, forming a fretwork of open shapes very different from the solid, massive forms of the past.

127 Egyptian pyramids Photograph The Metropolitan Museum of Art

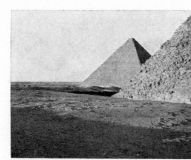

128 Stonehenge Photograph by Harold Allen

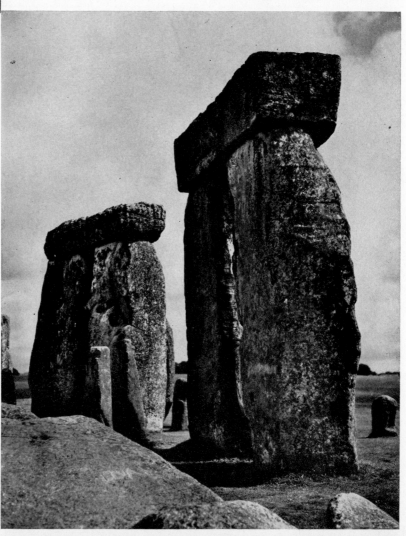

129 Radio antenna tower Courtesy Architectural Book Publishing Co., Inc.

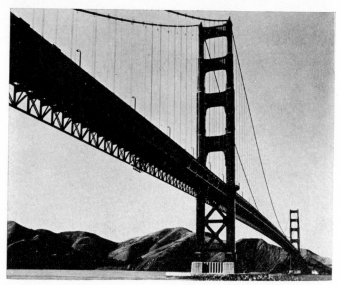

130 Golden Gate Bridge Photograph by Brett Weston

Transparent or Opaque

The design engraved on a Chinese bronze depends on an opaque surface for its full effect, but the lines incised on this crystal jug were conceived in terms of transparency and are intended to be seen superimposed on each other through the crystal.

131 Rock crystal jug and cover Kunsthistorisches Museum, Vienna

132 Chinese Bronze Lei (detail) The Art Institute of Chicago

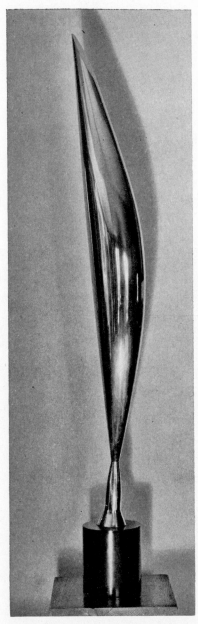

133 BRANCUSI *Bird in Space* Louise and Walter Arensberg Collection, Philadelphia Museum of Art

Brancusi's famous "Bird in Space" has sometimes been called "Bird in Flight," because across its highly polished surface light and reflections move with great speed, suggesting the upward movement of a flying bird. In contrast to the shiny metal, Brancusi chose a dull, almost porous stone for his sculpture, "The Kiss." Here he made sharply defined shadows accentuate the solidity of two static forms, a solidity which might have been dissipated by reflected images from the outside.

Three-dimensional or Flat

"I say that the art of sculpture is eight times as great as any other art based on drawing, because a statue has eight views and they must all be equally good. . ." Benvenuto Cellini, in making this statement, emphasized the difference between flat and three-dimensional form. The figure by Maillol, when photographed before three mirrors, shows four views of the same nude, all equally important. Each slight variation in the observer's position changes the appearance of the figure, for, indeed, there are not only eight possible views but an infinite number and this the artist who works in three dimensions must keep in mind if sculpture is truly to be conceived "in the round."

135 MAILLOL *Seated Nude*

The Art Institute of Chicago Photograph by Richard Brittain

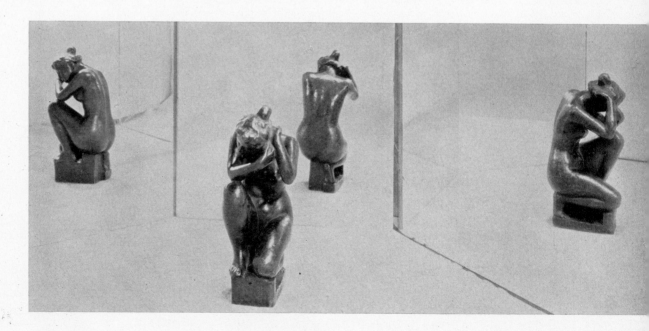

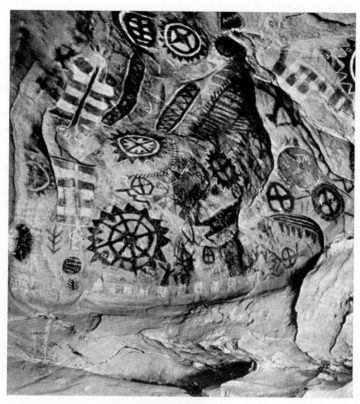

136 Pictograph from a cave near Santa Barbara

Surrounded or Free

How the artist places his work in space—whether it is free, surrounded or continuous—is often prescribed by the materials used. Practically no boundaries existed for the cave man who decorated his home with complete freedom. For him there were no walls broken by windows, no demarcations between floor and ceiling, no variety in surface material. He simply drew at will whenever and wherever he wanted. A pictograph from California shows how impulsively cave designs were scattered around without preliminary plans or restricting barriers. Never again was the artist to have such liberty.

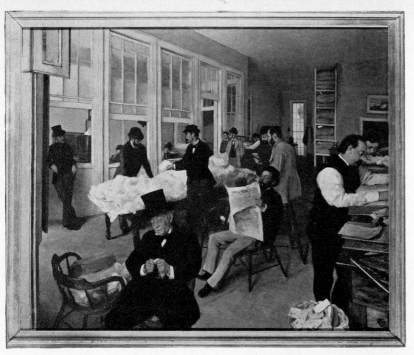

137 DEGAS *The Cotton Market in New Orleans* Musée de Pau

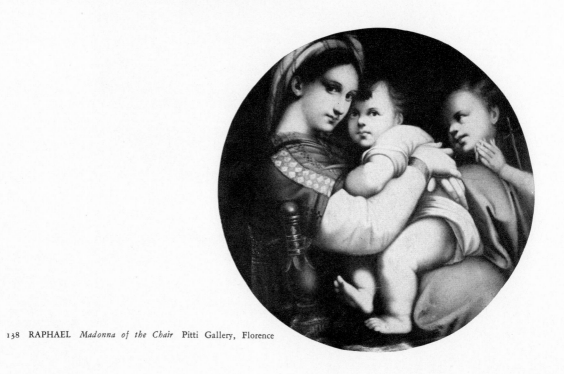

138 RAPHAEL *Madonna of the Chair* Pitti Gallery, Florence

The easel painter, unlike the cave man, always faces certain restrictions. He must design his canvas in terms of the frame which will enclose it. How Degas met this limitation is evident in a composition where repeated rectangles echo the shape of canvas and frame. Likewise the three figures in Raphael's "Madonna of the Chair" are circumscribed by the wood panel on which they are painted, their curves conforming to its round shape.

92

As paintings depend on frames, so book illustrations and illuminations are limited by shape of page and surrounding text, but sometimes, as with this thirteenth-century English manuscript, the artist sacrifices legibility to design. Even then the composition is seen in relation to the surrounding words. A Persian artist adapted his illumination more humbly, relieving a calligraphic text with curved forms isolated in a simple rectangle. Even the continuous pattern embossed on a round platter has definite borders, for though it neither begins nor ends, boundary lines contain its width.

139 Page from thirteenth-century English manuscript
The Art Institute of Chicago

141 Silver platter (English)
The Art Institute of Chicago

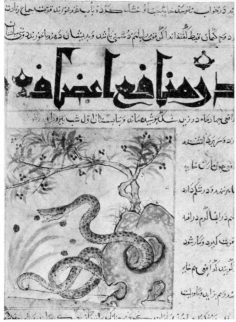

140 Page from fourteenth-century Persian manuscript The Art Institute of Chicago

93

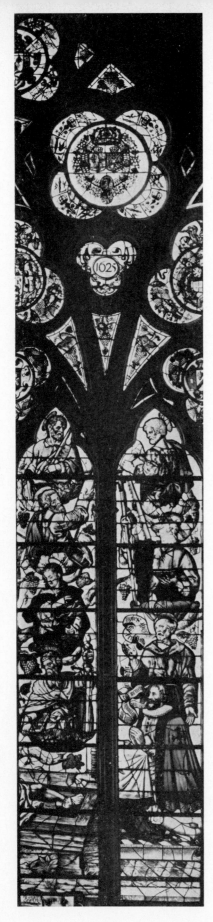

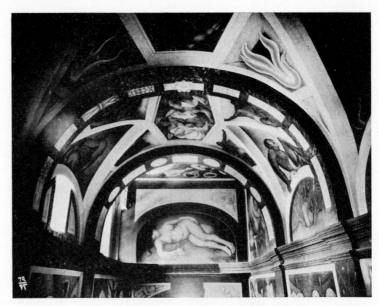

143 RIVERA Frescoes (College of Agriculture) Chapingo, Mexico

Stained glass windows are limited by the walls they pierce no less than murals by the walls on which they are painted, since both are circumscribed by architecture. Rivera adapted his frescoes at Chapingo to a vaulted ceiling, applied columns and cornices, while the size and shape of the windows at Troyes depend on the material and thickness of their surrounding walls.

142 Stained-glass window Cathedral of Troyes

Environment Conditions the Artist

The enrichment each man draws from his own environment is so deeply woven into the fabric of his art that it is difficult to consider one without the other. Hot climates, cold countries, temperate zones, the sea, mountains, cities, forests and plains—all of these affect the artist and influence his work. For him the religious and magic beliefs of his period are as important as the political and social milieu from which they grow. A few brief examples chosen from different times and places show how much the artist owes to his surroundings, for whether he lived in Alaska, medieval France, sixteenth-century Venice or nineteenth-century Paris, his work inevitably reflects the life around him.

The many wild animals found in the islands of southeastern Alaska provided a livelihood for the Indians of this region. The natives borrowed family and clan names from beasts, birds and fish and identified themselves with these creatures as they invested the animals with supernatural powers, building a complicated animistic society. Their art, usually carved from wood because this material was available, dealt almost exclusively with animal symbols. Characteristic is a nineteenth-century carving of a seated bear, a totemic symbol probably representing the chief of an important clan and used not unlike a crest or coat-of-arms, for in Alaska the bear, both useful and dangerous, came to be worshipped and feared.

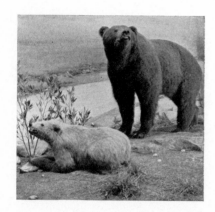

144 Alaska Brown Bears Photograph Chicago Natural History Museum

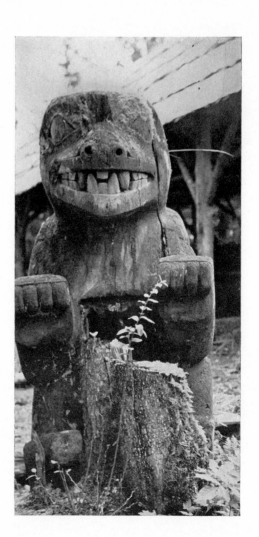

145 Woodcarving, Alaska Photograph by Paul and Paul

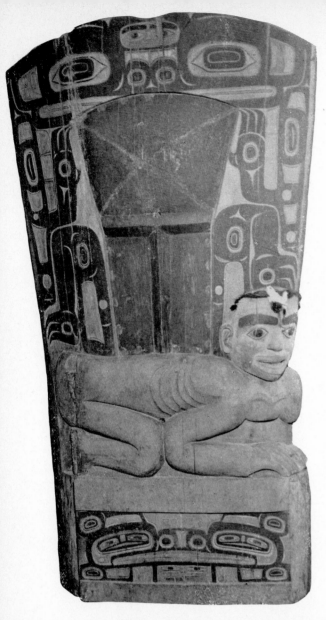

146 Indian House Post, Alaska Photograph by Paul and Paul

147 Detail of Indian House Post
Photograph by Paul and Paul

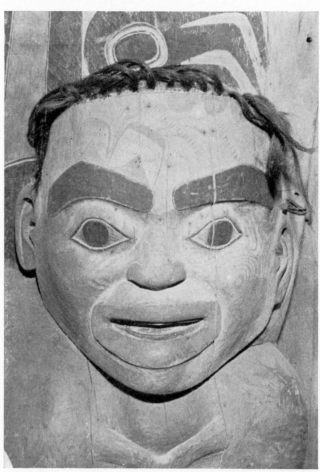

148 Raven in Alaska
Photograph Chicago Natural History Museum

A personified raven, represented as a crouching figure decorated with human hair, reveals how close was the identification between man and animal. Like other primitive people, the Indians of Alaska established communal groups where clan prestige was a distinguishing feature. Evidence is found in the carving directly above the raven where an object called a "chief's copper" symbolizes prestige, for to the chief alone was given the privilege of carrying this "shield" during important ceremonies. Because it was made of copper its value increased in the eyes of a people accustomed to wood. The same form, found repeatedly in the art of the Northwest coast, appears in British Columbia where two cemetery figures of painted wood resemble chief's coppers. Used here as grave markers, they again reflect the prestige of clan and family life.

149 Grave markers, British Columbia Photograph American Museum of Natural History

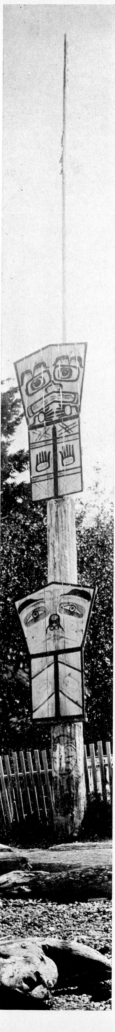

150 Chief's copper Photograph American Museum of Natural History

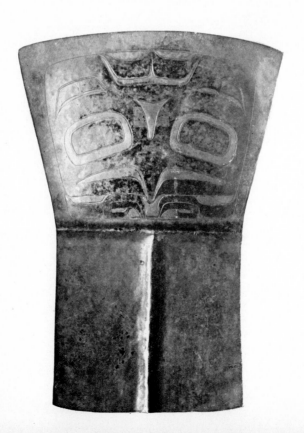

How different the Middle Ages in Europe! There it was not the animal kingdom or clan prestige which dominated life and art, but inner pressures of a far more sophisticated society. Man, dominated by the hierarchy of the Church, devoted a great part of his energies to the service of Christianity. Huge cathedrals were built, dedicated to the power of religion. As time went on, the Gothic church evolved, a soaring structure reaching vertically toward heaven, which, with its upward sweep, inspired awe and reverence. Buildings of lightness and height were encouraged by the invention of the flying buttress, an external support permitting stone masonry to be opened by large and frequent windows.

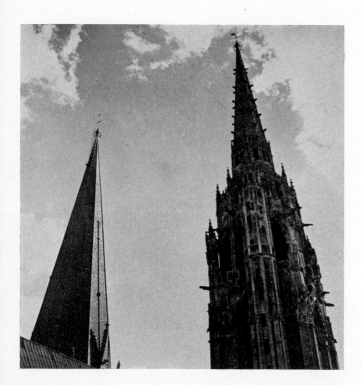

151 153 Chartres Cathedral Photograph by Peter Pollack

152 Notre Dame Photograph by Peter Pollack

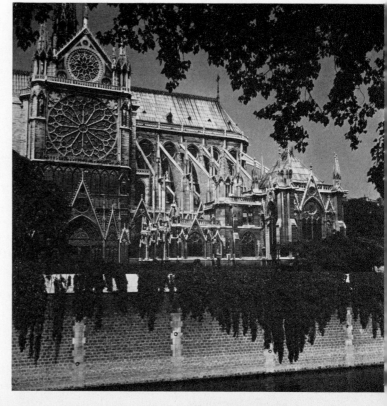

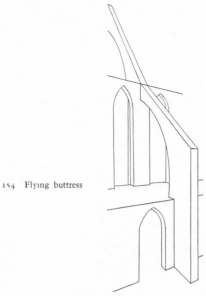

154 Flying buttress

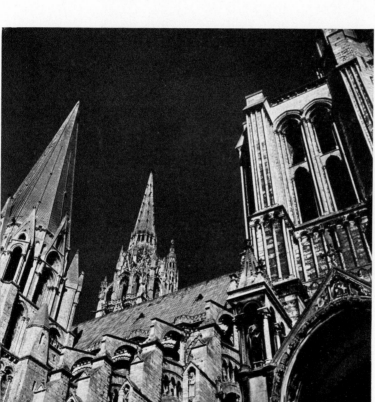

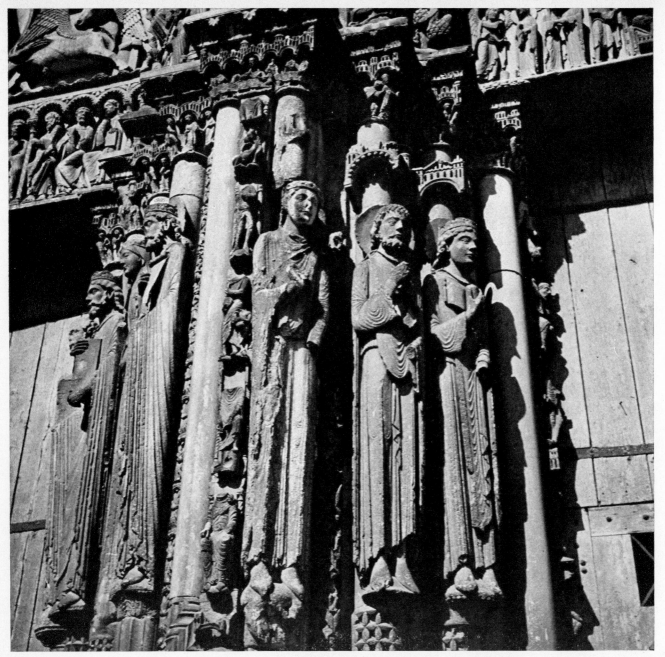

155 Sculpture, Chartres Cathedral Photograph by Peter Pollack

Medieval sculpture inevitably grew out of the architecture it decorated and, with elongated saints and virgins carved from stone, echoed the vertical lines of the churches. Paintings of this period, also influenced by religious fervor, show how complicated was Christianity's hierarchy. Often, as in this painting of "Christ Bearing the Cross" by Barna da Siena, the size of the figures is directly related to their religious prestige, Christ here towering over the humble figure of the praying donor.

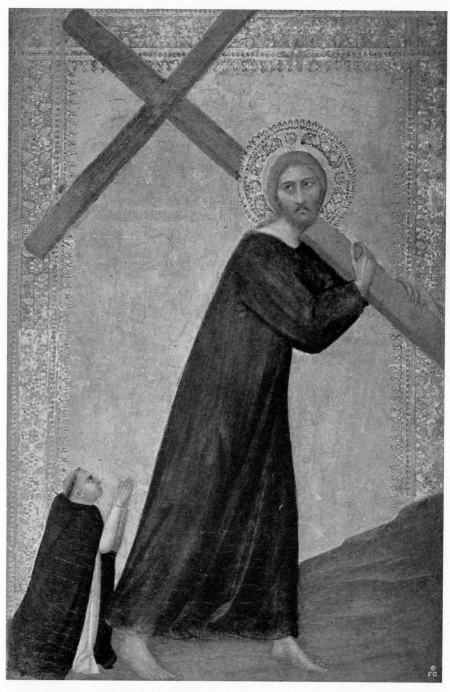

156 BARNA DA SIENA *Christ Bearing the Cross with Donor* The Frick Collection

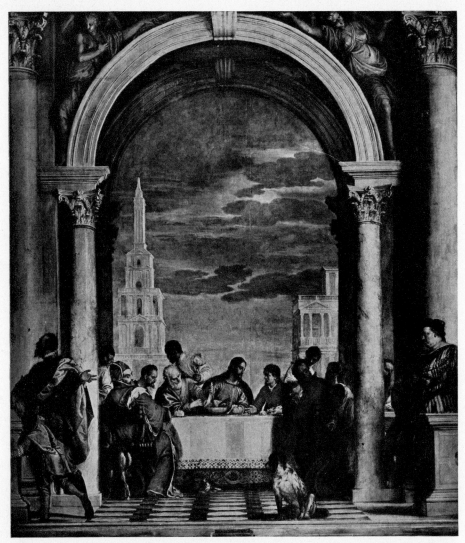

157 VERONESE *Feast in the House of Levi* (detail)
Royal Academy of Fine Arts, Venice

In Venice during the sixteenth century the Church was still strong, but medieval idealism had been transformed into frank materialism. The wealth, pomp and sensuous magnificence of the period were reflected by contemporary artists. Particularly lavish were the huge compositions of Veronese, often bearing religious names though far removed from spiritual fervor. The "Feast in the House of Levi" had originally been painted by him as a version of "The Last Supper of Christ," but, because of its highly secular nature, its overdressed attendants and emphasis on food and drink, the Church Tribunal forced Veronese to change the title.

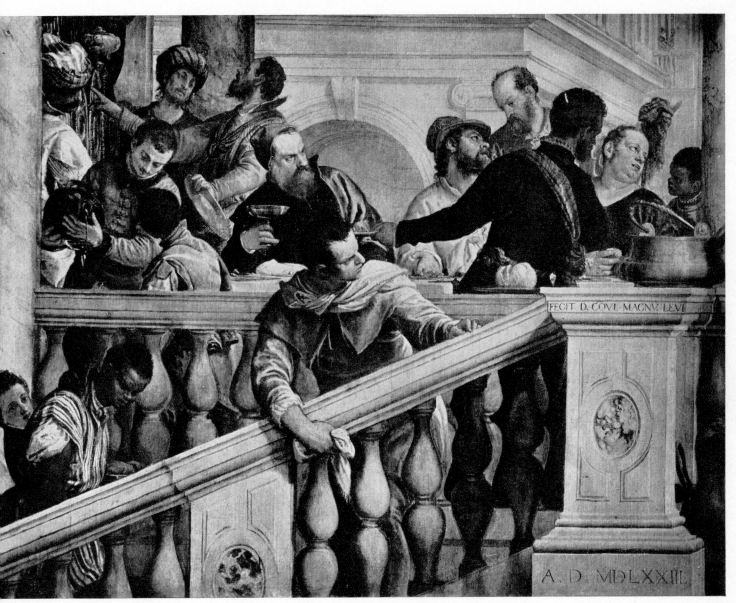

158 VERONESE *Feast in the House of Levi* (detail) Royal Academy of Fine Arts, Venice

159 Sixteenth-century Venetian textile The Metropolitan Museum of Art

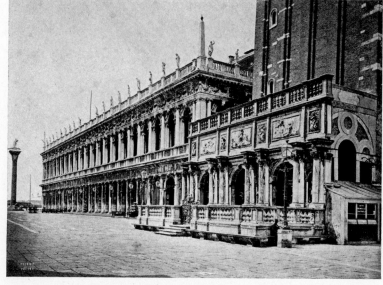

162 Sixteenth-century Venetian architecture

160 Sixteenth-century Venetian slippers The Metropolitan Museum of Art

163 Sixteenth-century Venetian chest The Metropolitan Museum of Art

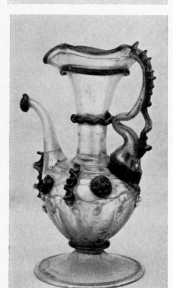

161 Sixteenth-century Venetian glass cruet The Metropolitan Museum of Art

164 VERONESE Painting on ceiling of the Royal Academy of Fine Arts, Venice

Veronese was the product of his environment no less than the Indian carvers of the Northwest coast or the medieval sculptors of Chartres. The materialism of his art is borrowed from the world around him, from the rich textiles and ornamented costumes, the handblown glass, carved chests and regal architecture produced in sixteenth-century Venice. When he painted the ceiling of the Academy of Fine Arts he had no difficulty adapting himself to its ornate architecture since his own work was a part of the same tradition.

Because Paris was becoming more congested in the nineteenth century, artists were tempted to escape from the city by working in the country or in various parks. As a result landscape painting grew more popular and artists in France developed the so-called *plein-air* (out-of-door) school, mainly devoted to the study of sunlight. Seurat chose the Grande Jatte, a wooded island in the Seine, as the setting for his famous painting. In 1885, a year before he completed it, a photograph of a French river bank was taken and shows how much he owed to the life around him. His figures are placed in similar positions and dressed in similar clothes.

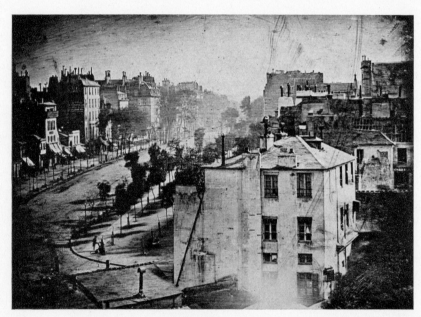

165 View of a Parisian street, 1837. Photograph by Daguerre.
Courtesy Museum of Modern Art

108

166 SEURAT *Sunday on Grande Jatte Island* The Art Institute of Chicago

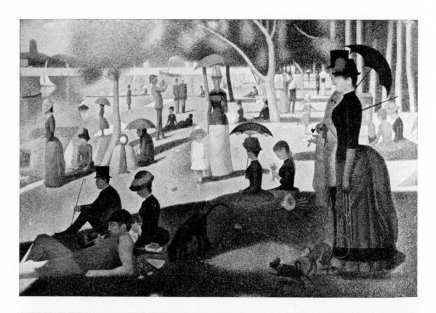

167 Riverbank in France, 1885
 Courtesy Arts et Métiers Graphiques

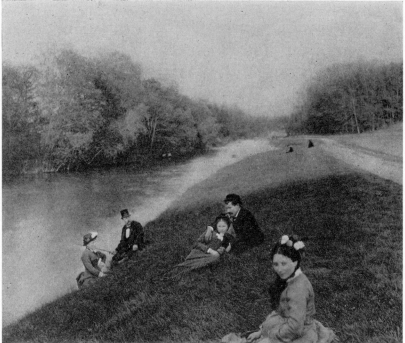

More important to Seurat than local customs were the new scientific discoveries of the nineteenth century, particularly those related to optical color laws. *The Scientific Theory of Color* by N. O. Rood, *Phenomena of Sight* by David Sutter and Chevreul's *Principles of Harmony and Contrast of Colors* were among the books he studied, hoping to understand better the relationship of color to the human eye. He wished to do more than *represent* sunlight as the Impressionists had; he wanted to make his painting a source of light. To this end he devised a new technique, using a complete palette of pure color and applying pigment in dots small enough to blend when seen at a distance—a method known as the optical mixture. Chevreul's influence is evident when a color detail from the "Grande Jatte" is compared to one of his charts, for Seurat learned from him that complementary colors, applied in small contrasting areas, make for greater luminosity.

168 Color chart by Chevreul

169 Detail of Illustration 166

The Twentieth Century

A kaleidoscopic view of twentieth-century life provides clues to twentieth-century art, not because of obvious similarities but because these similarities grow from common roots. Our age of science and technology has produced speedier forms of transportation and communication, a new architecture, industrialized cities, slums, modern warfare, timesaving gadgets, machinery of breath-taking proportions and technical inventions which have revolutionized daily life. These same forces have fashioned the art of our century.

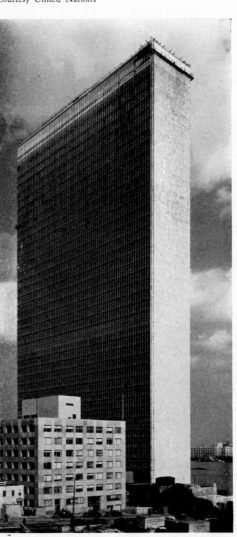

171 Secretariat Building of the United Nations
Courtesy United Nations

170 Photograph by Charles Lichtenstein

172 Photograph by Charles Lichtenstein

174 Photograph by Charles Lichtenstein

173 Photograph by Robert Capa

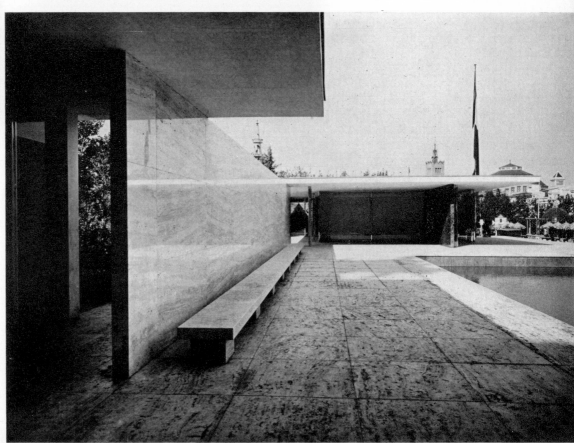

175 MIES VAN DER ROHE
Barcelona Pavilion

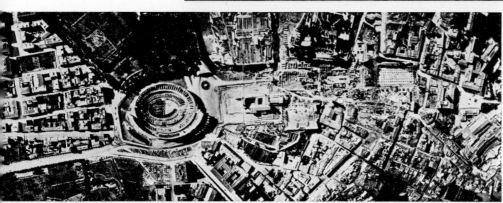

176 Air View of Rome

115

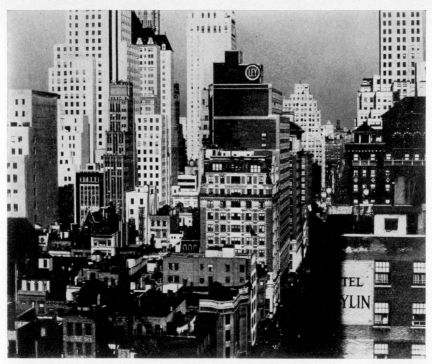

177 New York from *An American Place* Photograph by Alfred Stieglitz

178 Photograph by Virginia Lockrow

116

179 *Americana* Photograph by Ansel Adams

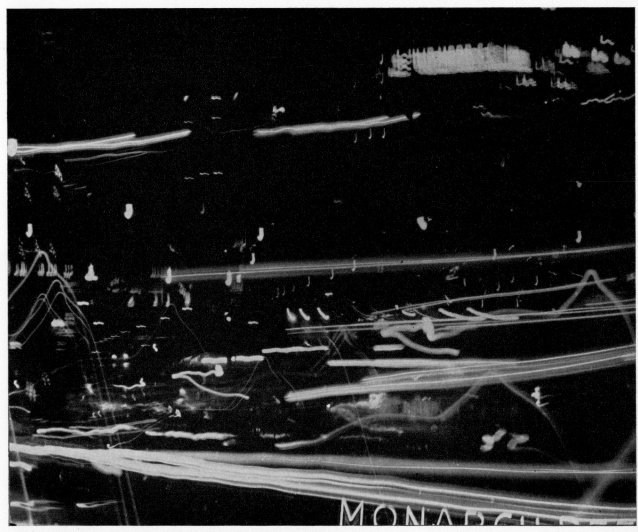

180 *City Lights* Photograph by Gyorgy Kepes

181 Photograph by Charles Lichtenstein

182 Photograph by Virginia Lockrow

During the last fifty years knowledge and experience have been extended, increased and accelerated, but with the resulting speed comes added complexity. Streetcars moving in one direction, elevated trains in another, pedestrians walking on busy thoroughfares with automobiles shooting by, innumerable printed signs and directions, magazines and newspapers distributed with relentless insistence—these are some of the simultaneous experiences which confront and confuse present-day people. The airplane, the radio, motion pictures and television, each with a new kind of speed or immediacy, necessitate additional adjustments, particularly for eye and ear. Because of the overlay of contemporary life and because twentieth-century man is bombarded by numerous visual and auditory stimuli at one and the same time, present-day artists have developed a new vocabulary to interpret these surroundings. In their work appears repeatedly an emphasis on simultaneity, a desire to show quickly all sides of an object, all phases of an experience at one time, the entire motion, the total psychological content in one concerted impact. It is almost as if the pressure of time had necessitated a visual speed-up not unlike the economic one associated with the assembly line and mass production.

Simultaneity

As early as 1910 the Cubists were concerning themselves with the problem of **simultaneity**. Starting with a known object as their point of departure, they tried to show all sides of it at one time—front, back, sides, inside, top and bottom. In short, they wanted to depict the *entire* object visually in a single experience. How, then, did they do this? These five drawings demonstrate an underlying principle of cubism. The first shows one view of a guitar; in the next four, step by step, as the instrument becomes transparent, it literally opens up, allowing many other sides to appear. These are twisted, rearranged and superimposed on each other to make a new composition. Any number of designs are possible, depending entirely on the will of the artist and the way he combines his material. In this case, the sixth drawing is an early cubist version of a guitar by Picasso. The five preliminary, hypothetical sketches show the possible stages which produced this work, how Picasso may have rearranged lines, forms and surfaces to achieve not one, but many views of the guitar in a single picture. Thus cubism may be defined as the breakdown or disintegration and arbitrary reassembling of the object.

183-187 Drawings by Kathleen Blackshear

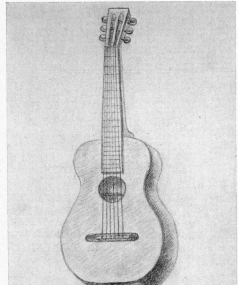

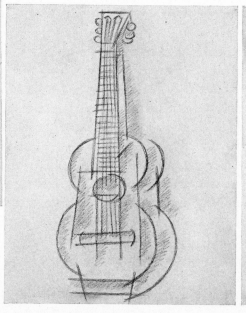

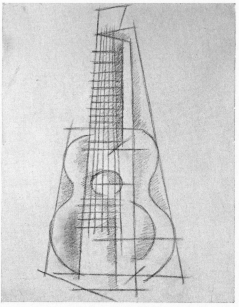

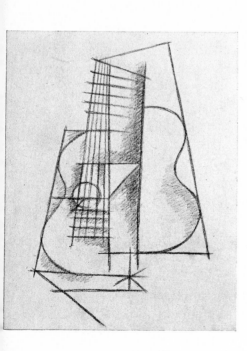 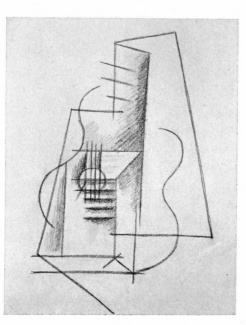 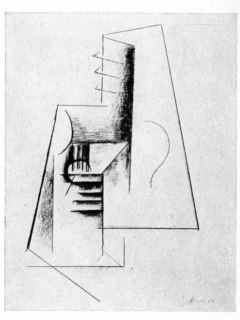

188 PICASSO *Guitar*
Collection Mrs. Milly M. Rosenwald

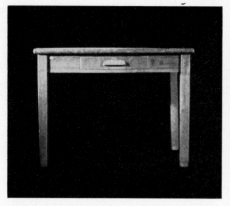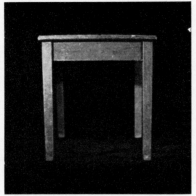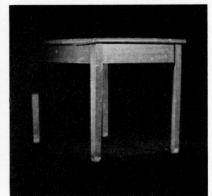

189-195 Photographs by Charles Lichtenstein

Obviously this method permits the artist great freedom. Despite the fact that he uses a known object as the basis for his work, he may still take liberties, showing combined aspects which ordinarily escape the eye. These various photographs of a table give further evidence of the wide choice open to the Cubist. The first three are front, side and angle views, the fourth shows the top of the table and the fifth, its underside. The two final photographs, made by combining the others, are different, because in the first, all five sides have been used, but in the second, the top of the table was omitted and the other views reassembled in an entirely different relationship. There are, of course, numberless other possibilities depending on how the photographer superimposes his material and what material he chooses to include. This also holds true for the artist. Picasso's cubist painting, "The Table," recalls but does not resemble these cubist photographs of the same subject. However, when the process he used is understood, the table's various forms and surfaces emerge, much exaggerated it is true, and we see how carefully the artist has recombined them into a new, closely knit composition. In this way the same table offers unlimited opportunities for fresh designs.

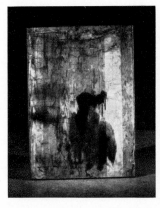 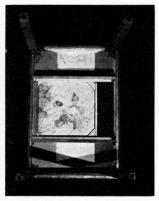 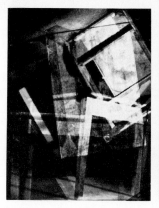 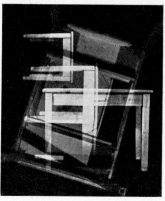

196 PICASSO *The Table* Smith College Museum of Art

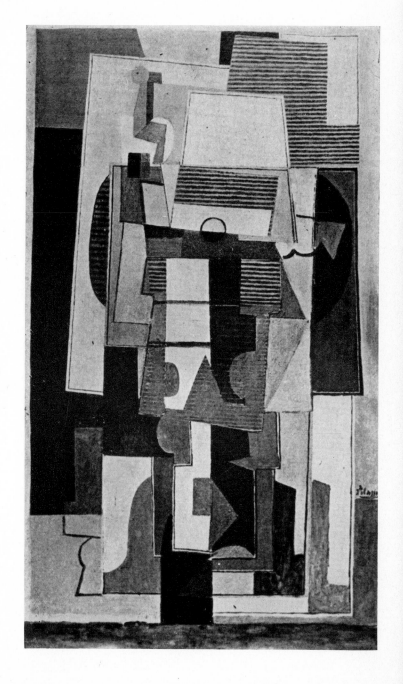

Futurism, developing only a few years after cubism, was concerned with motion. Whereas the Cubists combined all sides of an object **simultaneously**, the Futurists wanted its complete motion at one time. Their aim was not so much to *suggest* motion, as had been done in the past, but actually to depict and capture it on canvas or paper. This they tried to do by a series of overlapping forms which illustrated the path of the object as it moved through space. They did not want merely to show a man running; they wanted to show the *running* of a man, in fact the continuous running of a man at a given time. This in a sense was a cinema technique and evolved not unnaturally during the early years of motion picture history. Further, since the movement developed in Italy just prior to the First World War, its insistence on change and motion anticipated impending conflict. But futurism did more than suggest current restlessness, it also reflected mechanistic aspects of the period. For example, its relationship to the present interest in stroboscopic photography is evident when Balla's painting of flying birds, made in 1913, is compared with a recent fast-motion photograph of a tennis racket. The painter, in naming his work "Swifts: Paths of Movement and Dynamic Sequences," tells us precisely what he was trying to do. By the overlapping of transparent bird forms, he hoped to depict the undulating course of their flight. The flying bird interested him less than the speed and direction of its flight. Likewise Edgerton's stroboscopic photograph catches in a split second the swirls and eddies made by a tennis racket. The player, the ball and the racket can all be distinguished, but, because of repeated overlapping views, the path of their motion is what we really see.

197 BALLA *Swifts: Paths of Movement plus Dynamic Sequences* Museum of Modern Art

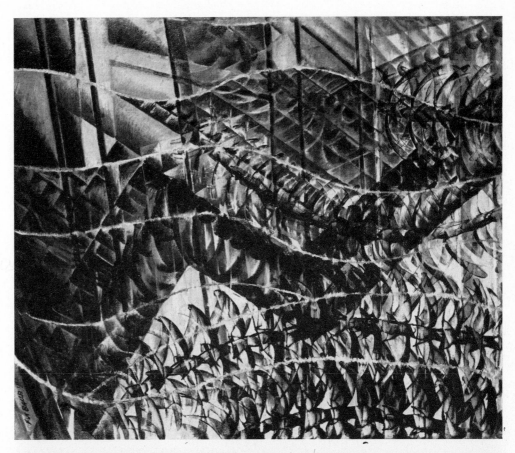

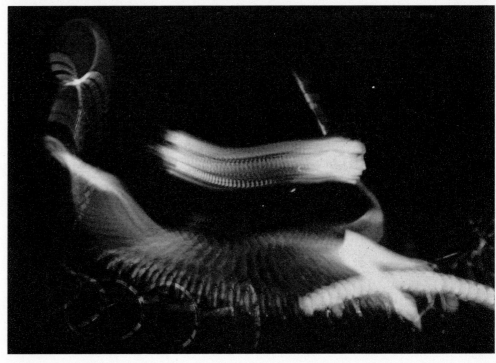

198 *Swirls and Eddies of a Tennis Racquet* Photograph by Harold E. Edgerton

199 DAUMIER *Fright* The Art Institute of Chicago

Even before the twentieth century, artists intuitively understood the implications of this technique and Daumier in his drawing, "Fright," used overlapping lines to express a shaking, terrorized figure.

It was Marcel Duchamp who finally combined cubism and futurism, intensifying the idea of **simultaneity** by showing the complete form as well as the entire movement of a figure at one time. Though he has denied that his celebrated painting, "Nude Descending a Staircase," is associated with futurism, stating, "My interest in painting the Nude was closer to the Cubists' interest in decomposing forms than to the Futurists' interest in suggesting motion," still, movement plays a very important role here. In this case the artist has conveyed the idea of descending motion by overlapping the transparent forms of a figure walking downstairs. It seems logical that in 1912, when the Nude was painted, artists should have concerned themselves with the dynamics of movement, so integral a part of twentieth-century life.

200 DUCHAMP *Nude Descending a Staircase*
Collection of Louise and Walter Arensberg,
Philadelphia Museum of Art

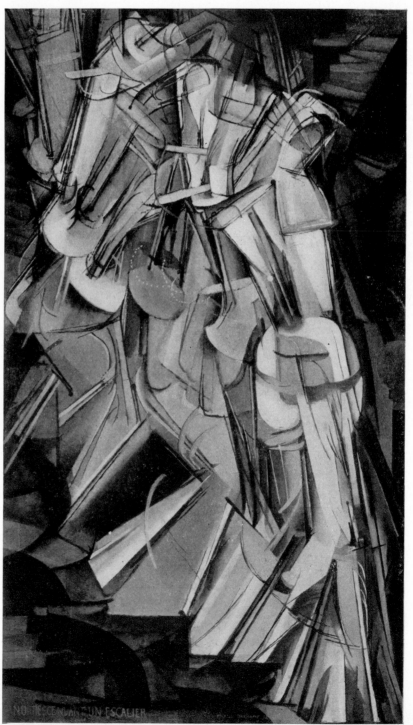

The desire to exploit changing aspects in the same work of art has caused artists to use transparent substances where new visions unfold as the painting or sculpture is seen against different backgrounds or with reflections cast on its surfaces. A painting on glass by Duchamp is shown in relation to various other pictures seen through it, but how different this same "glass" would look if placed in front of a window and viewed in terms of changing light and landscape. In 1949, more than twenty-five years after Duchamp completed this painting, he said, "We aren't dealing with any absolutes, are we, in this life. We are dealing only with that which is in motion, not [that] which is an absolute and fixed. . . ." The artist who chooses a transparent medium acknowledges the important role chance plays, for he often trusts his work to an unplanned, accidental background. When he designs, he must keep this in mind and arrange a composition which is enriched rather than obstructed by outside elements. A man, riding in a streetcar or any other modern conveyance, observes through the glass window numberless fleeting and superimposed scenes, such as moving electric signs reflecting on each other or networks of half-finished buildings or even a view through another window into a home or factory. He is having a **simultaneous** experience which many artists today are trying to interpret. The development of new transparent materials, especially plastics, tends to encourage further experimentation. A sculpture by Gabo is designed not only in terms of the objects seen through or reflected on it, but also in relation to itself, for the highly pliable plastic material makes possible a convoluted form where numerous sides can be viewed at the same time through its transparent walls.

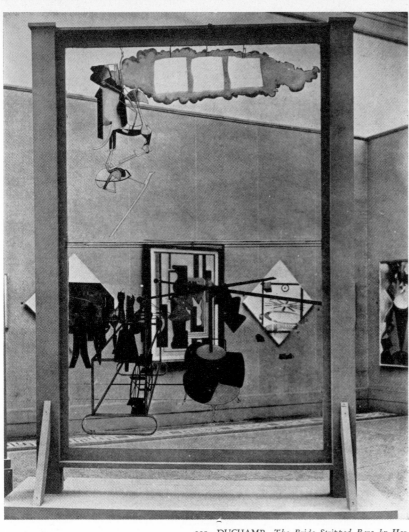

201 DUCHAMP *The Bride Stripped Bare by Her Own Bachelors* Collection Katherine S. Dreier

202 GABO *Spiral Theme* Museum of Modern Art

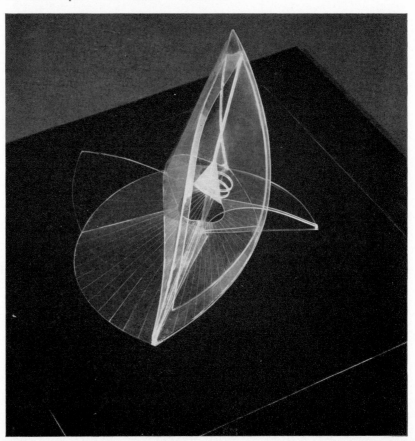

A new kind of sculpture with a new name, the mobile, has developed during our century and is a symptom of contemporary interest in motion. Heretofore sculpture, essentially static, sometimes suggested movement but did not itself move. The mobile, based on the idea that its various parts are flexible, is designed for motion and, as it moves, offers the observer innumerable different relationships. As a rule, the observer must move around three-dimensional sculpture to see it properly, but mobiles presuppose that both the sculpture and the spectator move. Thus many changing aspects can be seen almost **simultaneously**, depending, of course, on the rate of motion. Sometimes mobiles are operated by motors, but more frequently they are left to the gentle pressure of wind and breeze. It is not alone mechanized forms which have influenced the mobile, but nature, too, with its intricate moving shapes. Paradoxically, many artists have chosen forms in nature which recall the perfect synchronization of modern machinery, observing with new eyes the leaves, twigs and branches of a tree all moving at the same time or the subtle balance of an active human body. A wood and metal construction by Calder, when at rest, has none of the interplay and rhythmic variety which distinguishes it in motion. The sculptor, with astute precision, has used a machine to set in motion forms borrowed from nature, relating his figures in such a way that movement does not confuse but integrates them. These dancers, not dependent on naturalistic anatomy, are vitalized only in the process of *dancing*, their fragile movement made possible by steel wire and sheet aluminum, both light, modern materials. It is necessary to remember that the mobile, though three-dimensional, is conceived more in terms of space than form. Sculptors of the past were apt to use heavier materials and to plan their work for a given spot, but the contemporary artist, interested in moving sculpture, uses flexible metals, making them cut dynamic paths through space. One need only observe a modern city to realize how urban life also subdivides space with its jutting buildings, artificial changing lights, elevated billboards and swooping traffic.

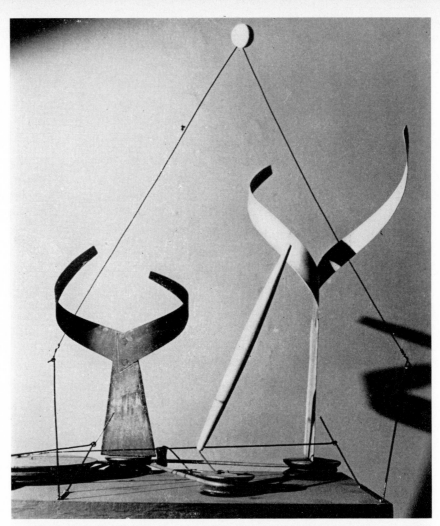

203 CALDER *Dancers and Sphere*
Collection the Artist

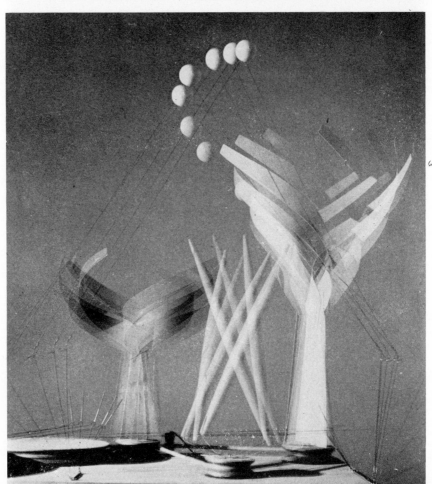

204 CALDER *Dancers and Sphere*
(In Motion)
Collection the Artist
Photographs by Herbert Matter

131

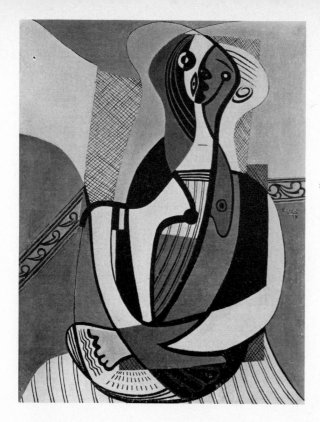

205 PICASSO *Seated Woman* Museum of Modern Art

In recent years certain painters have concerned themselves with rotating motion, suggesting it on a flat surface with conducting lines. Whereas a mobile can actually rotate, a painting or drawing, circumscribed by canvas or paper, must use associative devices to indicate rotation. Picasso developed this idea in "Seated Woman" where heavy curved lines juxtaposed against angles of chair and room make a continuous vision which unfolds various sides of a woman turning slowly within the canvas. He superimposed transparent planes of her body and face on a front view, allowing the observer to see all sides of the woman at once, not reassembled in a new design as in cubism, but as a total rotating figure. To do this he simplified the planes of her body, intensifying the feeling of rotation by unbroken curved lines and by exaggerated views of the head and body seen in different turning positions. Here Picasso is more interested in rotation than in the representation of a woman; he has merely used her form to express a specific kind of motion in space. We have seen how artists in the twentieth century, sometimes by suggestion, sometimes with real materials, use superimposed transparent forms to interpret a world of speed and immediacy where the human being becomes less interesting than the activity around him. Several years later, in a brief drawing Picasso eliminated superimposed transparent forms and, with line alone, made a double head suggesting psychological as well as physical changes. This head does more than rotate; it seems also to move up and down because its displaced features appear at different eye levels. Picasso's drawing is a short cut, showing **simultaneously** the combined motion and emotion of the head, for its expression changes no less than its position.

132

206 PICASSO *Head of a Woman* Museum of Modern Art

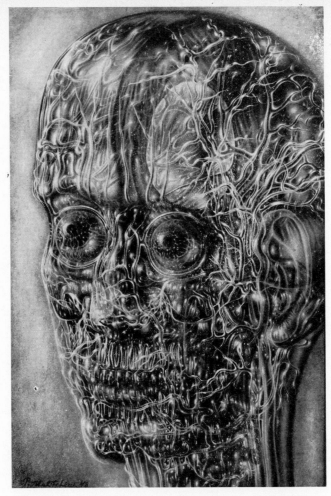

207 TCHELITCHEW *Twilight Head* Courtesy Durlacher Brothers

Influences of the X-ray technique have been felt by certain contemporary artists who paint transparent outer surfaces revealing detailed views of inner structures. In this way the observer sees **simultaneously** both the exterior shape and the interior content of a given form or figure. Tchelitchew's "Twilight Head" with its eerie translucency gives the feeling of motion not by movements of the head, as was true of Picasso's rotating figures, but by iridescent intertwining veins within the head. In our world of delving science, where medical research lays bare the interior of human bodies as psychoanalysis probes the interior of human minds, it is not surprising that an art form developed which depends on a combination of physical and psychic elements. Tchelitchew's head, though based on an objective X-ray view, implies far more by its frightening psychological intensity. Complicated inner workings of the human mind are suggested in addition to anatomical structure, for the artist infers that one may depend on the other. Tchelitchew obviously does not intend to mirror the technique of an X-ray but to improvise, using its influence as the basis for an interpretative rather than factual statement. These staring eyes and clenched teeth, these exquisite veins fluttering over cavities and bony forms suggest both life and death, or at least a kind of life which is irrevocably connected with death, for here living tissue does not hide the encroaching skeleton.

134

Expressionism, a new art term in the twentieth century, has more than one meaning, though it chiefly implies emotional "expression." When artists sacrifice naturalistic appearance to completely personal interpretations by exaggerating color, line, form and space, they produce the emotional feeling of a scene rather than its visual counterpart. John Marin, in a water color of New York, makes the spectator feel as if he were moving through the confusion of a busy city street, surrounded by traffic, noise and changing lights. This is not the way Fifth Avenue *looked* but the way it *felt* to Marin. By using various eye levels, staccato lines and superimposed images, he "expressed" with multiple impact many **simultaneous** city experiences in a single scene. He was not concerned with continuous motion as were the Futurists, but with emotions experienced in the presence of conflicting movement.

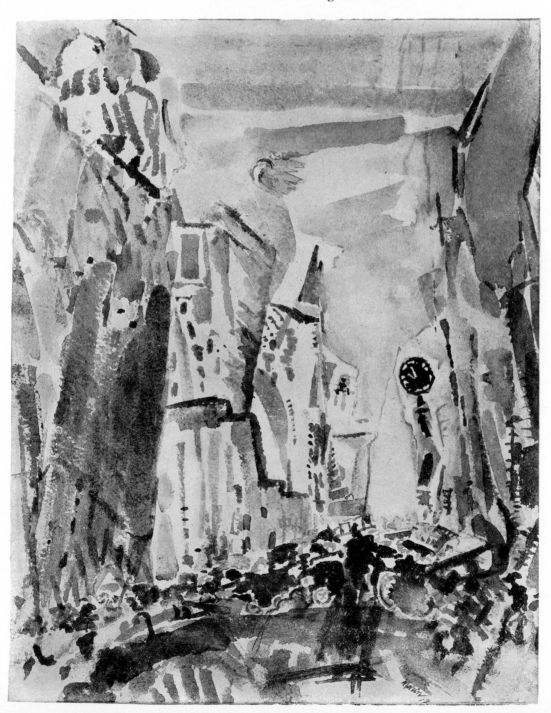

208 MARIN

Movement, Fifth Avenue, 1912

The Art Institute of Chicago

Artists today, living in a period dominated by the clock and timesaving devices, have evolved their own shorthand methods. Instead of a common system such as stenographers use, each artist has developed his own condensed symbols, **simultaneously** combining several ideas in one simplified version. Thus Ozenfant in "Composition" uses economic outlines as contours for neighboring forms, one line often substituting for several. Notice how the handle of a pitcher defines one side of a carafe, the spout, part of a bottle, while a lower section of the same pitcher outlines the top of another carafe. This method, sometimes called "the optical pun," makes for a tightly integrated composition where every line functions overtime. As in a picture puzzle, each shape, rigidly planned in terms of its neighbor, fits into a niche in an interrelated design. On the other hand, Paul Klee is apt to be less functional and more psychological when he condenses symbols. In a painting called "Lady and Fashion" he used a few brilliant lines to suggest the curved form of a woman and the stiff angles of a dress pattern, causing a witty contrast to convey subtle overtones of meaning. His method seems to belie his purpose, but the title gives a clue. By placing the primitive symbol of a woman's soft body next to the proud shape of fashion, he makes a comparison more profound than might be expected from such simple means.

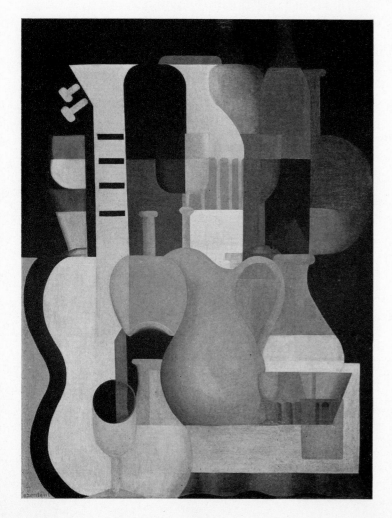

209 OZENFANT *Composition* Collection Robert Allerton

210 KLEE *Lady and Fashion* Courtesy Buchholz Gallery

Brancusi condenses both form and meaning, occasioning an intensely **simultaneous** experience. "The Princess" on first glance suggests the sensuous beauty of a woman, but on further study reveals the strong phallic symbol of a male. By combining both sexes in one figure, the extent of their interdependence is stressed and the sculpture is imbued with double meaning.

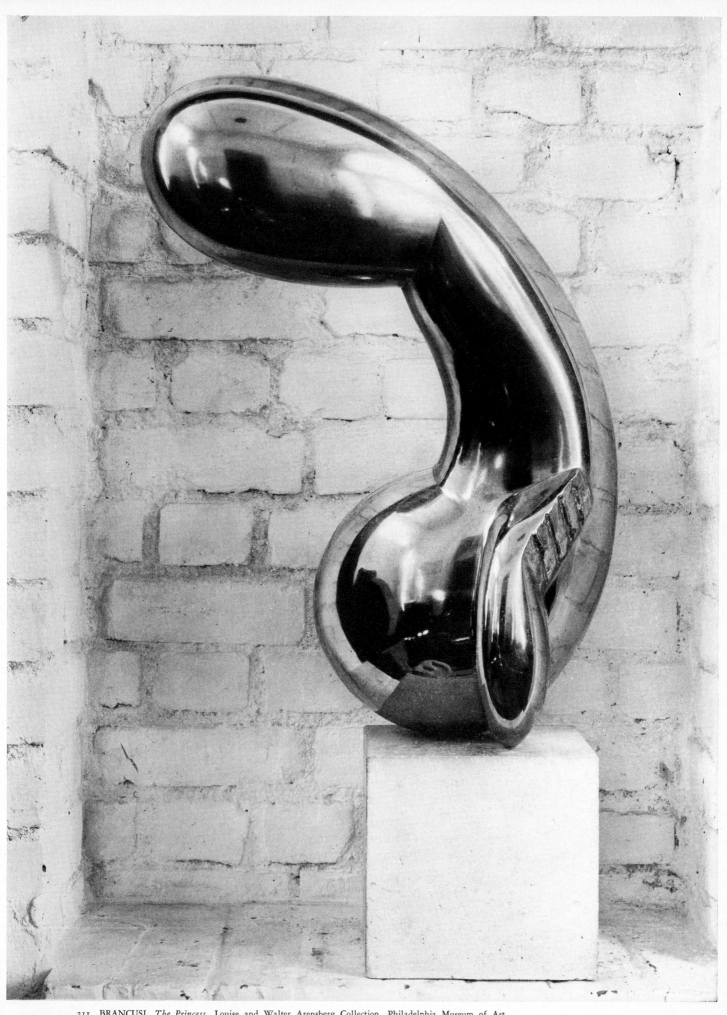

211 BRANCUSI *The Princess* Louise and Walter Arensberg Collection, Philadelphia Museum of Art

Freudian experiments with psychoanalysis are responsible in part for the development of surrealism, an art movement characterized by psychological **simultaneity**. Time barriers are eliminated and the artist arranges a combination of subconscious experiences on a single canvas where the past, the present and intervening psychological states are superimposed. Much like the irrational and disconnected content of dreams, surrealist art, disregarding normal time sequence, is concerned with overlapping emotions more than overlapping forms. A painting by Dali, composed of four seemingly unrelated groups placed in a lonely landscape, has an unreal dreamlike quality. Its meaning, perhaps clear only to psychoanalysts, is less important than the nostalgic mood induced by the strange disconnected forms and figures. When the painting is subdivided into four parts each section looks quite natural, despite minor inconsistencies. Because the picture was probably conceived in terms of various associated experiences drawn from different times in Dali's life, each single detail can readily be understood, but the composite becomes irrational.

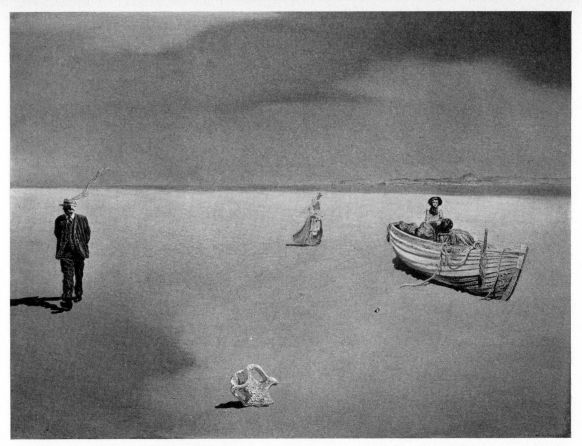

212 DALI *Paranoiac-Astral Image* Wadsworth Atheneum

213

214

216

215

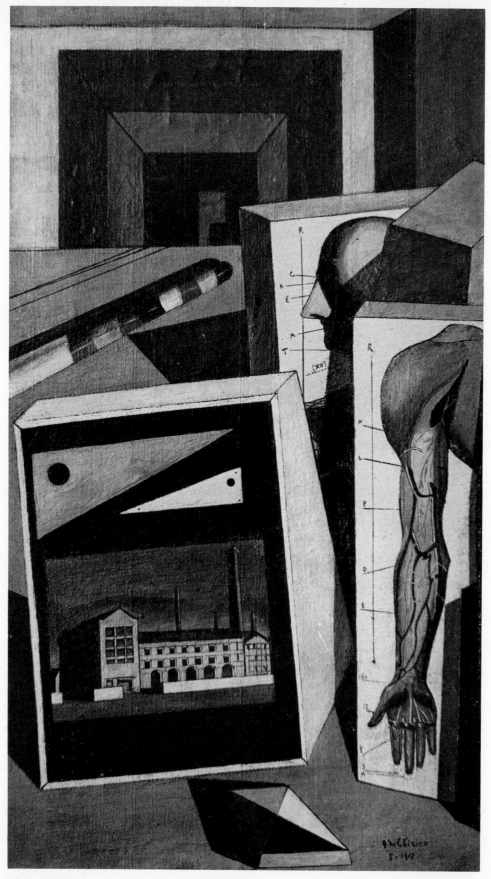

217 DE CHIRICO *Scholar's Playthings* Collection Mrs. Stanley B. Resor

A formula less secret than Dali's was used by Chirico, forerunner of surrealism, in a painting called "Scholar's Playthings," where he combined a series of related ideas rather than a series of psychological states. Many different symbols of scholarship are superimposed on each other to make a **simultaneous** composition. Tools the student needs, the building he works in or designs, the charts he studies or makes are among the "playthings" half-jokingly spotlighted in a composition whose very solidity infers the pseudo solemnity of the subject. Mérida, on the other hand, tries to correlate in a single drawing various emotional experiences which occurred at relatively the same time, differing from Dali's painting only in the degree of time covered. Both artists worked with highly personal material drawn from their own interior lives, but Dali allowed himself a longer time sequence. The central figure in Mérida's drawing was suggested by a regional toy whistle he saw in a Mexican town where he was living in the arcaded patio of an old building. He happened to break his leg at this time, so with crutches, whistle and arcade he took poetic license, combining subjective reactions in one brief pencil sketch.

218 MÉRIDA *Drawing*

219 Mexican toy whistle

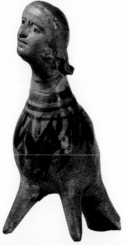

143

Because of the increased complexity of twentieth-century life, artists today react to their surroundings with greater diversity than those who lived in a more homogeneous period. Variations which appear in their work partly explain the observer's predicament, for while daily influences like the machine, the city, war and modern psychiatry have become source material for the artist, public understanding sometimes lags. To a man who has never ridden in an airplane the new panoramic perspective which grows out of this experience is confusing; so also are surrealist symbols to those who know nothing about psychoanalysis. With the recent extension and acceleration of knowledge come added difficulties for the spectator who sometimes fails to understand art forms which result from experiences he may not have had, but the artist, with more acute sensitivity, often intuits an unfamiliar situation and makes it his own. Such possibly was the case when Van Gogh painted "The Starry Night." Though not trained in astronomy he instinctively chose from this field the forms he needed, making his spinning stars resemble rotating nebulae. He wrote, "When I paint a sun, I want to make people feel it revolving at a terrific rate of speed, giving off light and heat waves of tremendous power."

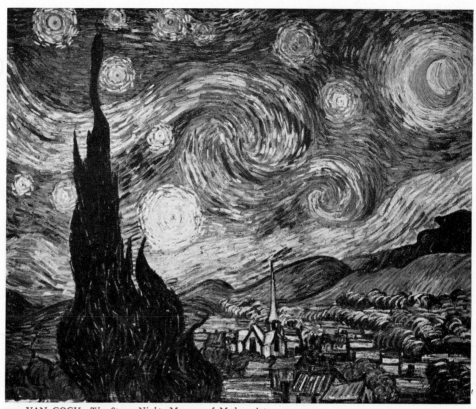

220 VAN GOGH *The Starry Night* Museum of Modern Art

221 Spiral Nebula Photograph Mount Wilson and Palomar Observatories

The Machine

The machine, a recurrent theme in contemporary art, has been interpreted with great variety. Certain artists tend to mirror it, like Sheeler when he painted this picture called "Mechanization." Hard forms and smooth surfaces define images of real machinery in a design appropriately severe. In contrast, Fernand Léger, less interested in the idea of real machinery, tries to make a machine out of his painting by arranging a composition which operates with mechanistic precision. Though his picture, "The Wounded," concerns the human body, the forms he has chosen recall machine parts and are so related that they suggest mechanical interplay. One or two of the ballbearing-like shapes have come loose and, like wounds, interfere with the efficiency of the figure, for Léger allows us to believe that a human body, no less than a machine or a painting, is coordinated with meticulous precision.

222 SHEELER *Mechanization* Collection John Hay Whitney

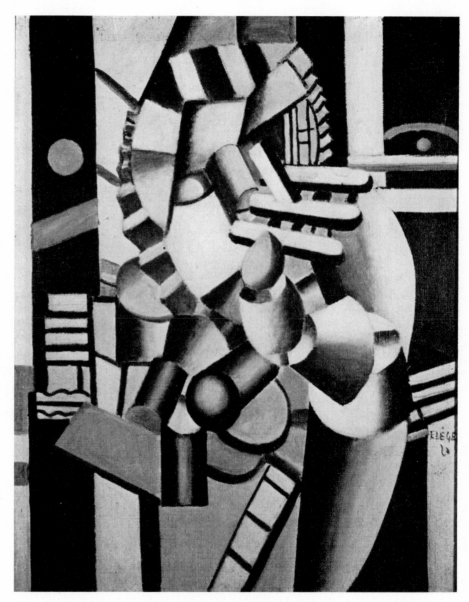

223 LÉGER *The Wounded* Courtesy Pierre Matisse Gallery

Marcel Duchamp finds different relationships between man and **machine.** In his work he mechanizes the human being and humanizes the machine. "The Bride," a new kind of anatomical structure, half-human, half-mechanistic, is well adapted to an age when machinery, made for and by man, ironically becomes master. Sometimes described as a "complex motor running on love gas," "The Bride," with paradoxical overtones, is at once humorous and macabre. Erotic forms are arranged in a complex design recalling the sterilized interior of a modern scientific laboratory. Duchamp suggests that in our highly mechanized surroundings even love must bow to the measured efficiency of the machine.

224 Photograph by Torkel Korling

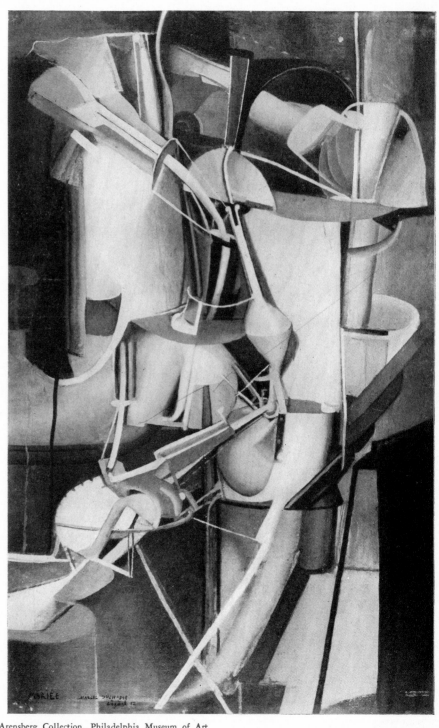

225 DUCHAMP *The Bride* Louise and Walter Arensberg Collection, Philadelphia Museum of Art

Paul Klee's water color, "Little Experimental Machine," though less frightening than "The Bride," is equally satirical. With poetic symbols and delicate lines the artist reveals not the hard forms of traditional machinery, but a whimsical construction of lightly attached wires. He befriends the machine, relieving its infallibility with gentle wit, for this playful mechanism recalls casual forms in nature—weaving trees, butterflies and fluttering birds. The sculptor, David Smith, instead of finding nature in a machine, makes his landscape look like machinery. Here he works with steel and bronze to fashion a simplified garden complete with tree, bird and sundial, but he uses the prototype of mechanistic forms as the basis for his sculpture. Even its steel and metal frame grows from present industrialization and has a rigidity more related to factory than garden. All three of these artists, Duchamp, Klee and Smith, were aware of the machine not as an isolated phenomenon, but as a force coloring present-day thought and vision. With tongues in their cheeks, they married technology to man, animal and landscape, sometimes imbuing the union with supernatural power, sometimes with human weakness.

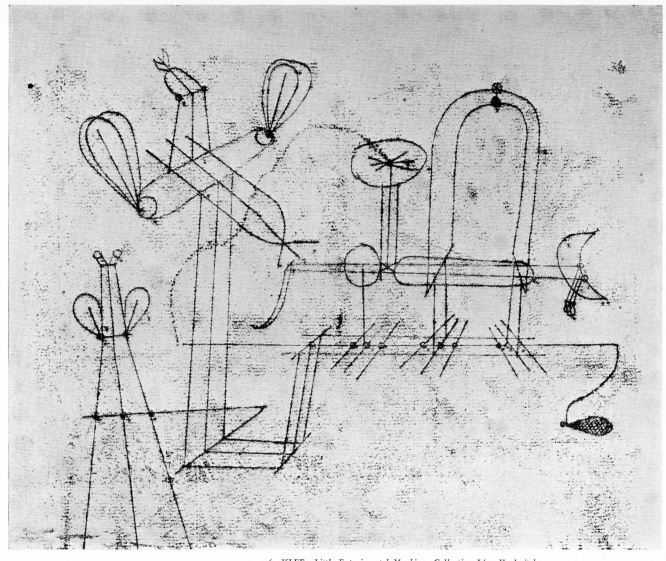

226 KLEE *Little Experimental Machine* Collection Léon Kochnitzky

227 DAVID SMITH *The Garden* Courtesy Willard Gallery

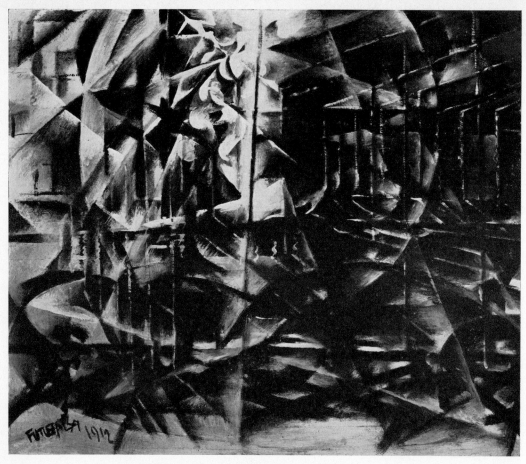

228 BALLA *Speeding Automobile* Museum of Modern Art

Mechanistic forms and their psychological implications have strongly influenced contemporary art, but so, too, has the power produced by machinery. For example, Balla was less concerned with the shape of an automobile than with the speed it created. In his painting, "Speeding Automobile," the futurist device of overlapping forms serves to emphasize motion rather than the engine which produced this motion. Likewise the airplane has left its imprint on twentieth-century art, for a new vision results from the kaleidoscopic experience of traveling *above* the earth. Whereas some artists, like Balla, presuppose the observer to be outside the vehicle watching its motion, others place him inside where he can look across or down at an everchanging pattern. Thus it is not the moving machine but the moving landscape which becomes interesting. Malevich was one of the first painters to concern himself with the airplane in relation to art. He studied air view photographs, incorporating new perspectives in many of his drawings. But his approach, more metaphysical than practical, led him to believe that "the airplane was not built to carry business letters from Berlin to Moscow." For him it evolved from the growing perception of speed, the emphasis our century has placed on accelerated motion. He understood that this new form implied more than a visual experience, that in essence it was both symptom and symbol of an expanding, fast-moving world.

229 MALEVICH Suprematist painting

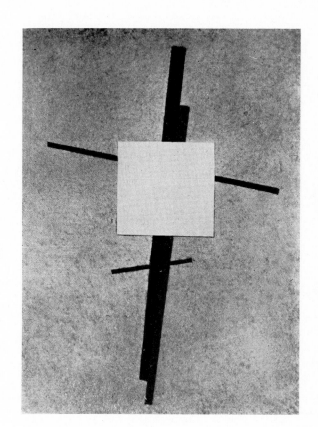

Other artists, less concerned with the philosophy of the **machine**, concentrated on more obvious patterns and designs resulting from air travel. If a painting by Julio de Diego, entitled "Altitude 3000," is compared with an air view photograph of the Triborough Bridge, certain similarities appear, though these two scenes, one in New York, the other in Mexico, are related only because they are both air views. De Diego's painting, made in high relief, picks out moving patterns which were suggested to him when flying over Acapulco. Curved forms recalled a serpent, the popular symbol of Mexican archaeology. Though the painting is far more fluid, far less descriptive than the photograph of the bridge, still the same diagonal perspective, the same diminution of scale exists in both, also a similar all-over design with horizon eliminated. Reversing this idea, Tamayo shows the tilted perspective caused by observers on land looking up at moving planes instead of passengers in the air looking down from them.

230 Air view of Triborough Bridge Photograph Museum of Modern Art

231 DE DIEGO *Altitude 3000* Collection the Artist

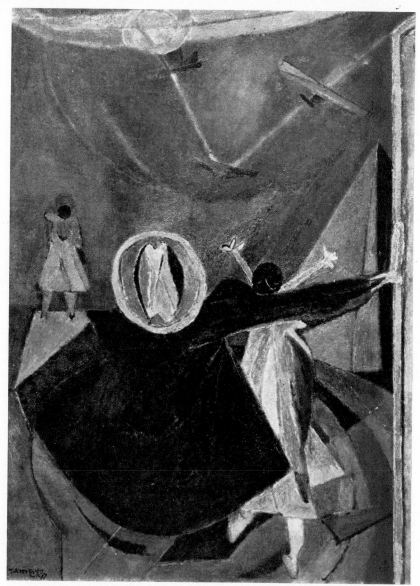

232 TAMAYO *Planes in Sight* Courtesy M. Knoedler & Co.

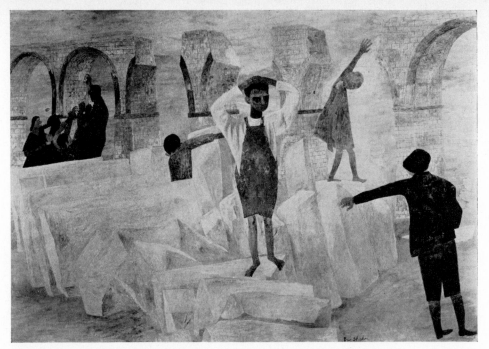

233 SHAHN *Reconstruction* Whitney Museum of American Art

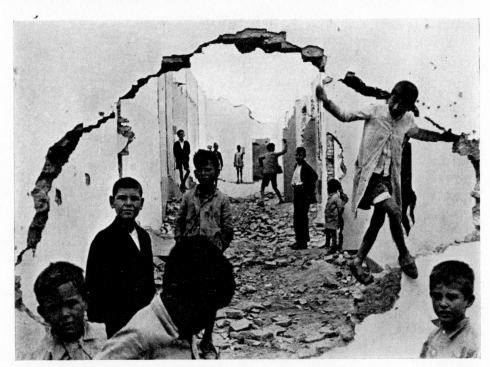

234 *Children In Ruins* Photograph by Cartier-Bresson Courtesy Museum of Modern Art

War

Artists of the present century, living under the constant shadow of war, reflect this depressing influence in a variety of ways. Sometimes the painter selects a single scene which grows out of a war experience and, by simplification, intensifies its meaning. Ben Shahn's tempera version of aimless children playing among ruins is close in feeling and appearance to a photograph of the same subject by Cartier-Bresson. Both outline small figures against the meaningless rubble of war and both, despite understatement, tell the same tragic story; but Shahn, by eliminating details and making his children almost transparent, emphasizes their hunger and detachment. George Grosz, on the other hand, uses opaque and transparent forms to show a different aftermath of war, not emaciated children but depraved adults. By permitting the observer to look through certain figures, he reveals their degradation. Instead of ruined buildings he shows ruined people.

235 GROSZ *Street Scene, 1918*
Courtesy Associated American Artists Galleries

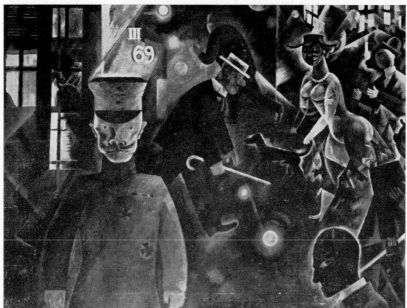

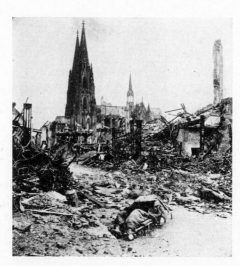

236

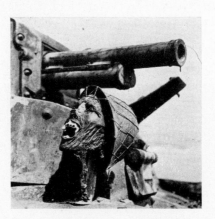

237

The erosions of war, where man and landscape are equally scarred, help to explain such frightening paintings as this recent portrait by Dubuffet. The head's deeply rutted surface suggests the mud, cinders and flinty dust caused by the explosions and upheavals of war, for this is not the portrait of a person; this is the malignant face of death and destruction.

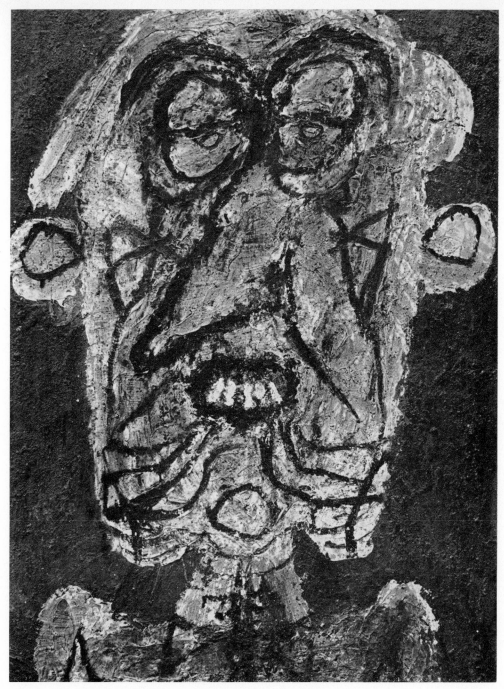

238 DUBUFFET *Grand Portrait Mythe Supervielle* The Art Institute of Chicago

These etchings, made by Otto Dix after the First World War, grow from the same diseased roots. Barbed wire, gas masks and destroyed bodies have become the folklore of modern **warfare**. Since the waste of twentieth-century battle is on such an impersonal and grandiose scale, artists can only hope to imply its meaning through familiar symbols.

239 DIX *Shock Troops Advance Under Gas* Museum of Modern Art

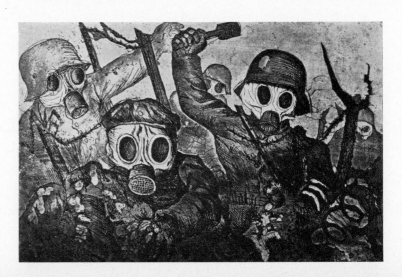

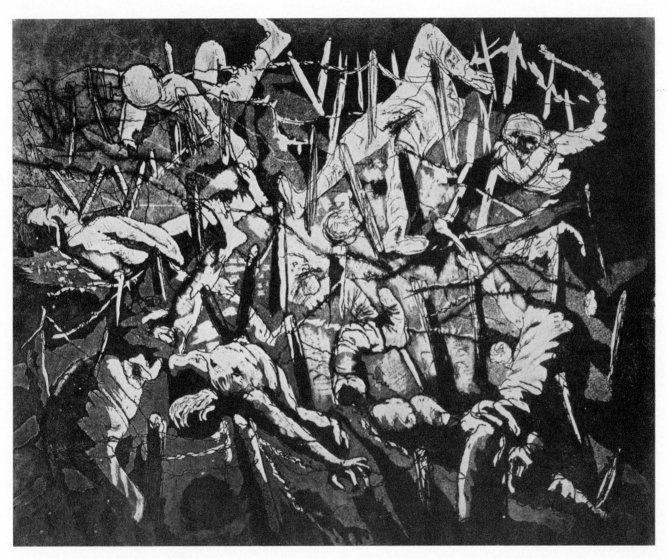

240 DIX *Dance of Death* Museum of Modern Art

War, like the machine, has become a basic theme today, but artists react to it with less emotional variety. So grim a subject rarely inspires indulgent humor. If three famous war paintings are compared, their common origin of fury, hate and disgust is evident, though the expressive methods used are different. Artists of this century have not idealized battle, nor is it war triumphant they depict, but rather death triumphant. Witness the apocalyptic indictment of Picasso's "Guernica." Tortured people and frightened animals are arranged in violent disorder, their emotions exaggerated to represent all the fear and horror of war in one composite account. Picasso has purposely included only those elements which contribute to brutality and fright, accentuating certain features, eliminating others. Sometimes he needs only a streaking head with outstretched arm, sometimes the full helpless body. Even his jagged composition, built on disturbing contrasts of light and dark with figures rotating and transparent forms revealing each other, emphasizes mutilation. Here meaning and form are so interwoven that a new visual language of fear is created. Dali, no less than Picasso, invents new symbols. His sadistic octopus-like figure portrays civil war, the same sick form dividing to devour itself. Compulsive fury is inherent in every deformed shape. Peter Blume's "Eternal City," though more explicit than the paintings by Picasso and Dali, results from similar emotions. Because his symbolism is partly literary, the picture is harder to read and its meaning is delivered with less immediate impact. But he, too, is concerned with the evils of war, not so much with those of actual combat as with those which cause it. Under and among Rome's classical ruins he depicts the misery and distrust which accompanied Mussolini's jack-in-the-box rise to power. On the left, worshippers pay hypocritical respect to the suffering of mankind, while off in the distance soldiers attack the people. Thus Blume paints the story of political corruption. Like Picasso's "Guernica" his picture refers to a given situation, but because of more literal symbols its meaning is less universal.

241 PICASSO *Guernica* Owned by the artist. Courtesy Museum of Modern Art

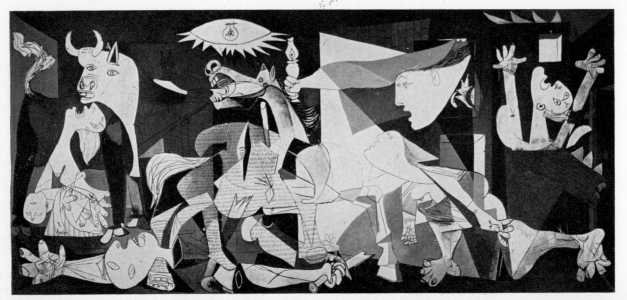

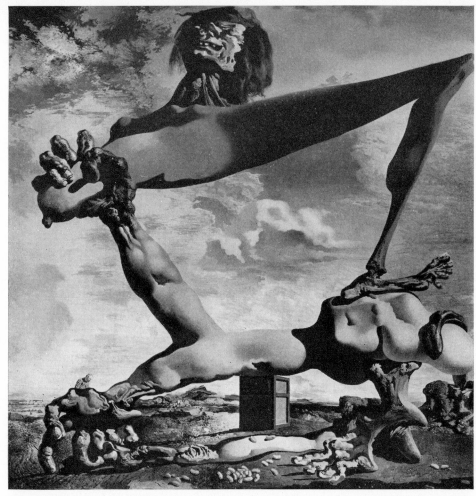

242　DALI　*Soft Construction with Boiled Beans; Premonition of Civil War*　Collection Louise and Walter Arensberg, Philadelphia Museum of Art

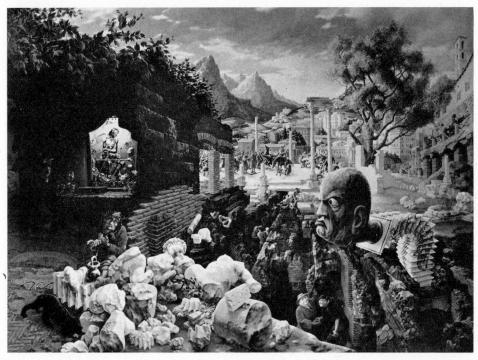

243　BLUME　*The Eternal City*　Museum of Modern Art

Psychoanalytic Thought

Freud has so revolutionized current language that psychological terms like frustration, neurotic, anxiety, sadism and narcissism have become household words and, today, even teen-agers try to analyze the underlying reasons for such familiar emotions as jealousy, desire and hostility. From the same source comes surrealism, a new art movement which is concerned chiefly with irrational dream material. The early Surrealists, in an effort to escape from the difficulties and boredom of everyday life, claimed that dreams were the only reality and that through them alone could emotions be freed; hence the name sur (super) realism. It is not surprising to find this movement developing in a world disturbed by constant political and economic unrest. When Chirico painted "Disturbing Voyage" in 1913 he was already foretelling surrealism and with psychoanalytic symbols was describing the kind of anxiety which manifests itself in dreams. Here many entrances, leading nowhere, demand a decision, but the pressure of an approaching train only intensifies the anxiety.

244 DE CHIRICO *Disturbing Journey* Museum of Modern Art

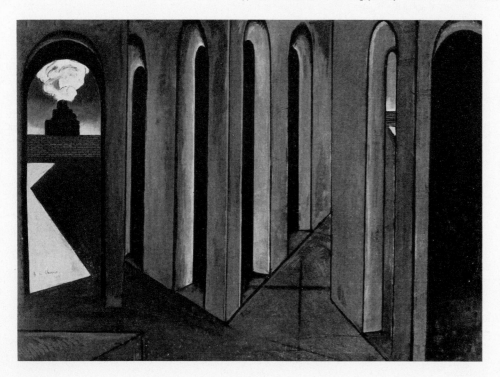

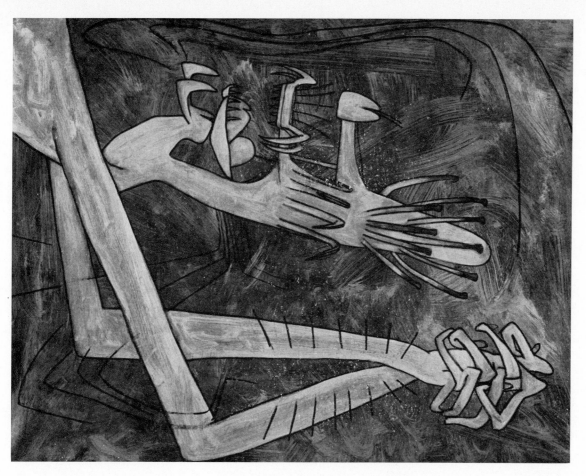

245 MATTA *Man Trembling* Courtesy Pierre Matisse Gallery

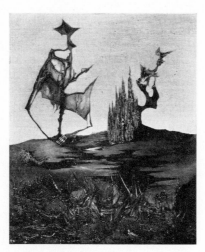

246 PAALEN *Totemic Landscape of My Infancy* Collection Peggy Guggenheim

A recent work by Matta, "Man Trembling," uses machinelike human forms to express the tensions of fear. Fright has so frozen the figure that arms and hands are interlocked like a paralyzed machine in a nightmare. When Wolfgang Paalen painted "Totemic Landscape of My Infancy" he was frankly autobiographical. These shapes drawn partly from the human body, partly from insects, trees and bushes, are evidently intimate dream symbols which represent emotional experiences of his childhood.

There is no doubt that, at times, surrealism is a private language which even experienced students of **psychoanalysis** cannot unravel unless they know the personal associations of the symbols used. This is true of Paalen's painting and partly explains the confusion experienced by observers who depend on literal meaning rather than pervading mood for their understanding. However, "Narcissus" by Kurt Seligmann treats of a more general subject, one which the Greeks early recognized and modern psychiatry has revived, for today narcissism has become the accepted term for self-love. Seligmann has not painted an image of the well-known classical figure, but instead has used disturbing symbols to express psychological effects. A convoluted form, literally wrapped up in itself, suggests the kind of emotional imprisonment which results from extreme self-love. With haughty posture the figure feeds upon itself. Less clear is Yves Tanguy's painting, "The Wish," where possible desire and frustration are implied. In a complex pattern the artist constructs an interlocking design of anthropomorphic and geometric forms which undoubtedly have psychological associations for him. Erotic shapes, eerie textures and exaggerated space make for a dreamlike combination where the central figure seems almost totemic. This is a new kind of totem pole, drawn from one man's associations with desire, but the nostalgic effect on the observer infers atavistic symbols of a more general nature.

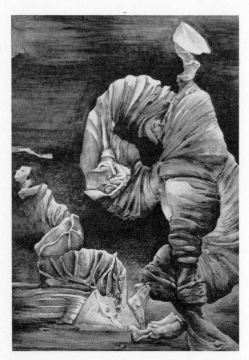

247 SELIGMANN *Narcissus* Collection Mr. and Mrs. LeRay W. Berdeau

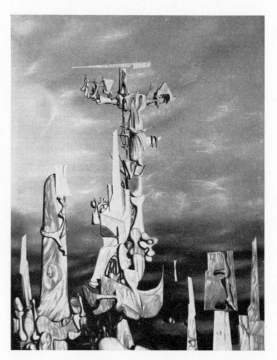

248 TANGUY *The Wish* Courtesy Pierre Matisse Gallery

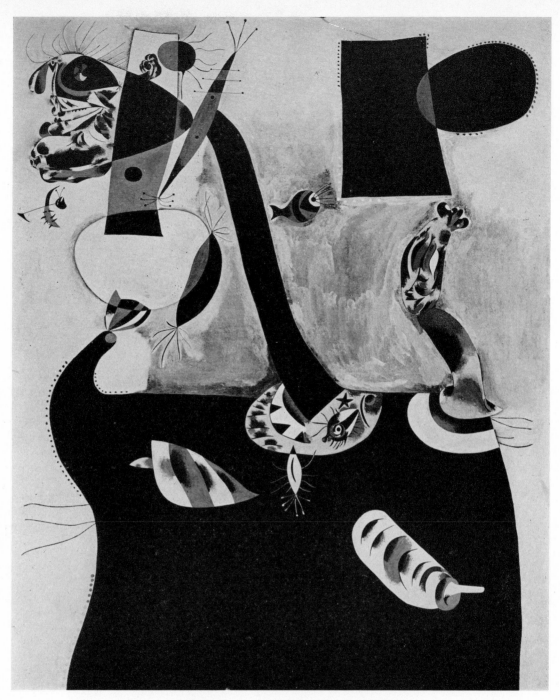

249 MIRÓ *Seated Woman* Collection Peggy Guggenheim

Miró's "Seated Woman" borrows obvious sexual symbols from experiments of Freud and his followers. Here, with the clarity of an irrational dream, the parts of a woman's body are divorced from traditional morality and come to life only as erotic forms. Phallic symbols appear repeatedly. The painting stresses the "femaleness" of woman, her power to arouse desire, her need for sexual union.

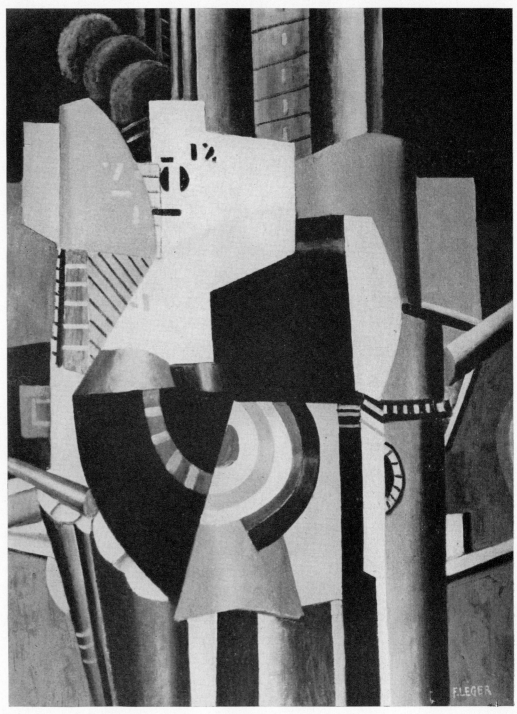

250 LÉGER *The City* Collection Louise and Walter Arensberg, Philadelphia Museum of Art

The City

Artists have always painted the city. But in our industrialized century the metropolis, grown to overwhelming proportions, has become a central motif in contemporary art. Its inhumanity, loneliness, confusion and sheer beauty are favorite themes for present-day artists, who sometimes reproduce its chaotic disorder, sometimes escape from this turmoil with works of precision and clarity. We have seen how John Marin in his water color of New York (Illustration 208) expressed the bewildering emotions caused by the impact of busy streets. Léger's purpose was different, for in his paintings he stressed the orderly coherence of complicated cities. With hard forms, bright color, geometric outlines and shiny textures he symbolized the power of industrialization in a synchronized design where rest and action functioned together. He understood how static forms, in the motion of real traffic and changing lights, sometimes by contrast seem more prominent than they would in quieter surroundings, so he arranged his moving shapes around fixed points. For him the city was like a beautiful machine. Edward Hopper saw its drabber aspects, the loneliness of unpretentious streets, the rectangles and long horizontals of plain façades. Even his hard light, so American in feeling, lays bare the seamy side of urban life, describing its monotony in a composition no less organized, though simpler, than Léger's. One man sees the city as an exciting stimulant, the other, more romantically, as a source of loneliness and isolation.

251 HOPPER *Early Sunday Morning* Whitney Museum of American Art

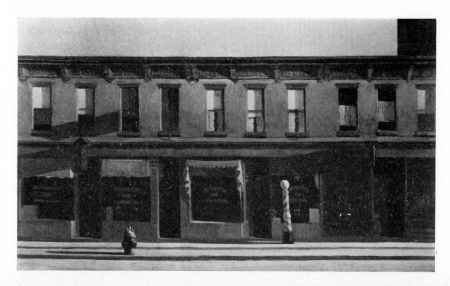

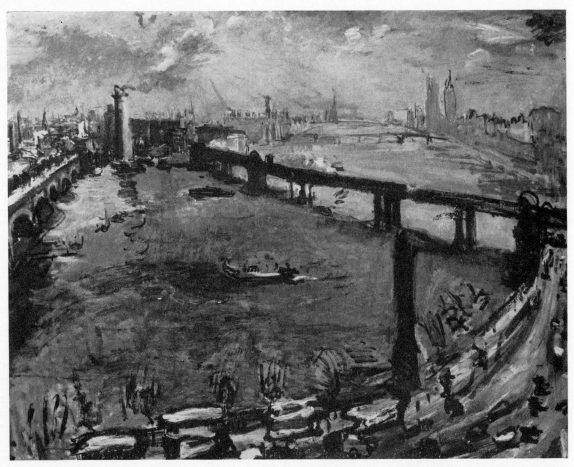

252 KOKOSCHKA *London Bridge* Albright Art Gallery

Even more romantic is Kokoschka's interpretation. His sweeping view of dazzling turrets and spacious vistas differs from the more solid statements of Léger and Hopper, for Kokoschka, concentrating less on the mechanistic or psychological aspects of the city, shows us its fleeting beauty. His painting is an impression, an attempt to unfold the vast panorama of London as it moves and changes in the sunlight. He sees it as a whole, not in detail, but as a miraculous visual experience without other implications.

170

O'Keeffe also sees its miraculous beauty, painting it at night when darkness is pierced by innumerable artificial lights and forms cease to exist. Buildings are almost annihilated, for only light and space remain, creating an illusion of perforated atmosphere where space is more important than surrounding form. O'Keeffe, who recognized how darkness simplifies the city by removing details which bombard the eye in daylight, used a consistently economic pattern where variations of light hollowed through forms. Like a Calder mobile (Illustration 204) or a transparent construction by Gabo (Illustration 202), this painting of a skyscraper at night exploits the reflections, motion and space which we identify with modern city landscapes.

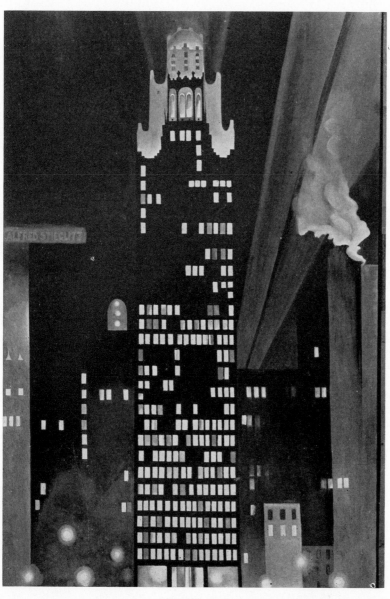

253 O'KEEFFE *Radiator Building—Night, New York* Collection the Artist

171

A painting by Lyonel Feininger called "City at Night" again demonstrates how space takes precedence over form, the irregular contour of the sky becoming more important than the buildings which shape it. Reginald Marsh also paints the city at night, but his interest is focused on people, not architecture. The picture, an explicit account of the bedraggled human jungle produced by oversize cities, requires little explanation. Candid-camera casualness, intensified by polyglot signs and dreary lights, selects a particular scene, allowing it to represent a larger world. Marsh, like many contemporary artists, incorporates various forms of lettering in his design, for he appreciates how much signboard and advertisement mean in our present visual life.

254 FEININGER *City at Night* Collection the Artist

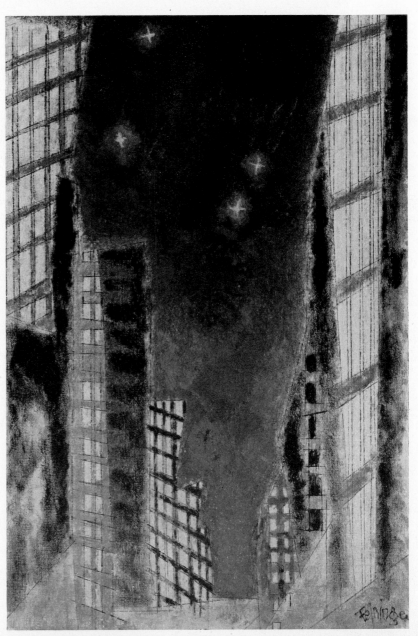

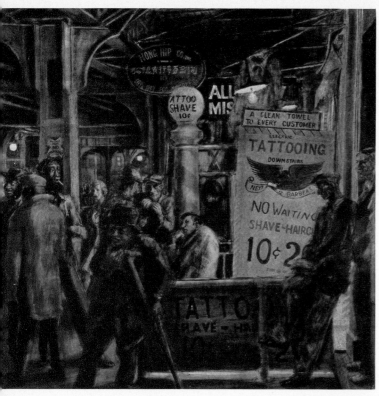

255 MARSH *Tattoo and Haircut* The Art Institute of Chicago

256 STELLA *Coal Pile* The Metropolitan Museum of Art

Though "The Coal Pile" by Joseph Stella, a charcoal drawing of limpid clarity, is not a city scene, its meaning is urban, for coal makes power and power makes cities. Stella endowed the drawing with poetry borrowed from everyday life, juxtaposing the heavy coal against a delicate metal conveyor. In the distance, two small telephone poles limit space and accentuate the scale and weight of the coal heap. Incidentally, here the use of charcoal was a particularly happy choice.

Gyorgy Kepes, too, has taken symbolic details to suggest a larger idea, but he has worked with less naturalistic means. In his painting, "City," the entire design is based on different kinds of pavement where varied patina and a pattern running continuously through the picture suggest streets and sidewalks. The artist implies that, though modern cities stretch up, a pedestrian has little opportunity to observe more than the pavement beneath him as he walks through busy thoroughfares. To Kepes the congested **city** is a limiting experience, because, as it closes in, the eye is too busy observing immediate obstacles and details to appreciate heroic architecture and sweeping space.

257 KEPES *City* Collection Herwin Shaffer

258 GRAVES *Black Waves* Courtesy Albright Art Gallery

259 *The Sea* Photograph by Ray Atkeson Courtesy Hastings House Publishers

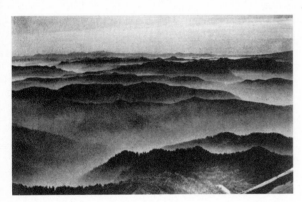

260 *Cascade Mountains* Photograph by Ray Atkeson Courtesy Hastings House Publishers

Today the complexity of metropolitan life sometimes forces artists to find less harassed surroundings. In the United States the wonders of pioneering are still not forgotten and the artist's language is close to the awe he feels for the land itself. As he reacts from the city, he discovers regional meanings in other parts of the country. Typical is Morris Graves who, living in the state of Washington, responds to the mysteries and grandeur of the Northwest landscape. His painting, "Black Waves," is an enigmatic combination of both the mountains and seacoast which dominate this region.

261 HIROSHIGE *Cuckoo and Moon* The Art Institute of Chicago

262 CHU TA *Lotos and Herons* Courtesy Oxford University Press

Like other artists on the West Coast, Graves is more familiar with Oriental art than colleagues living inland or on the Atlantic seaboard and he often paints the birds of his native Northwest with a tenuous transparency reminiscent of Chinese painting, arranging them in taut positions borrowed from the Japanese.

263 GRAVES *In the Air* Collection William R. Valentiner

264 *Taos Pueblo* Courtesy University of New Mexico Press

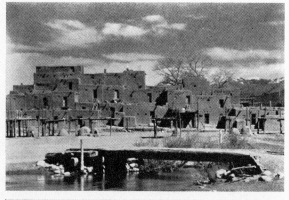

266 WELLS *The Village* Courtesy Durlacher Brothers

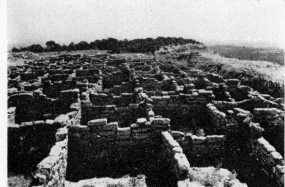

265 Indian Ruin in Southwestern United States Courtesy University of New Mexico Press

Very different is the work of Cady Wells who has chosen to live in New Mexico, a land of arid landscapes and indigenous Indian art. "The Village," one of his characteristic water colors, is loosely designed in terms of irregular rectangles, visually related to the ancient and modern Indian architecture of the Southwest. From eroded formations like this rock sheltering an old cliff dwelling come weird shapes and underground forms similar to those used by Wells in his water color, "The End," where rhythmic curves and shadows evoke memories of the earth's stratifications. Both Graves and Wells, by drawing deeply from the land around them, have tried to escape urban confusion and the pressures of contemporary life.

180

267 Indian cave dwelling Courtesy University of New Mexico Press

268 WELLS *The End* Courtesy Durlacher Brothers

The Twentieth Century

The rich and varied art of our century was born from the wonder, invention and violence of the last fifty years. Sensitive men, often aware of the same forces, have reacted to them with individual preferences. Thus Klee, Mondrian and Picasso, possibly the three most significant artists of the first half of this century, each developed his own language: Klee the idiom of wonder and poetry, Mondrian of order and structure, Picasso, a language of passion growing from the violence of our times. When Klee said, ". . . I do not wish to represent man as he is, but only as he might be," he explained his way of escaping from an imperfect world by inventing a new one of his own. Mondrian also looked for relief from the furious disorder around him but he chose a different way. He said, "It is thus clear that the artist has not become a mechanic, but that the progress of science, of technique, of machinery, of life as a whole, has only made him into a living machine, capable of realizing in a pure manner the essence of art." For him it was necessary to accept the world he lived in, to explore it and extract from it only those elements which made for order and harmony. Perhaps it was Picasso who most completely understood his times when he said, "Whether he likes it or not, man is the instrument of nature." He realized that art of all periods, including our own, is subservient to nature, be it human nature or the physical nature of the world around us. Greater than the desire to escape or the need to organize was his extraordinary gift for interpreting his surroundings, for understanding and translating them. He once said, "When I paint, my object is to show what I have found and not what I am looking for." Twelve years later he added, "It is my misfortune—and probably my delight—to use things as my passions tell me."

269 KLEE *The Gatekeeper's Pride* Collection Mr. and Mrs. Lee A. Ault

270 MONDRIAN *Diagonal Composition* Collection John L. Senior, Jr.

271 PICASSO *The Painter and His Model* Collection Sidney Janis

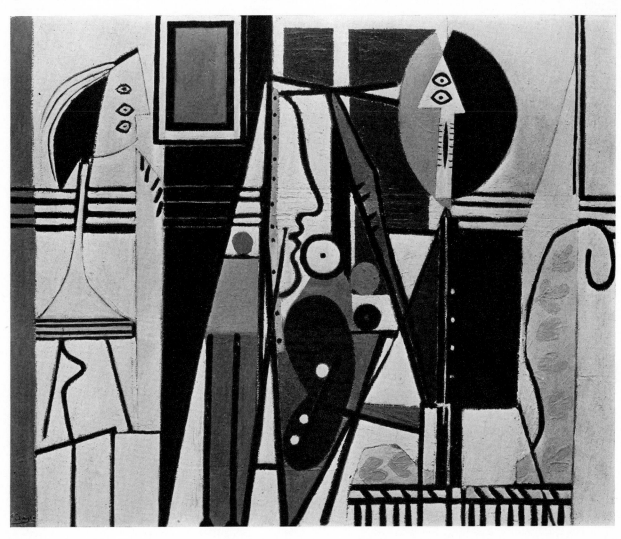